T0030226

ANTONIO CANOVA

Comitato Nazionale per le celebrazioni
del bicentenario della morte di Antonio Canova

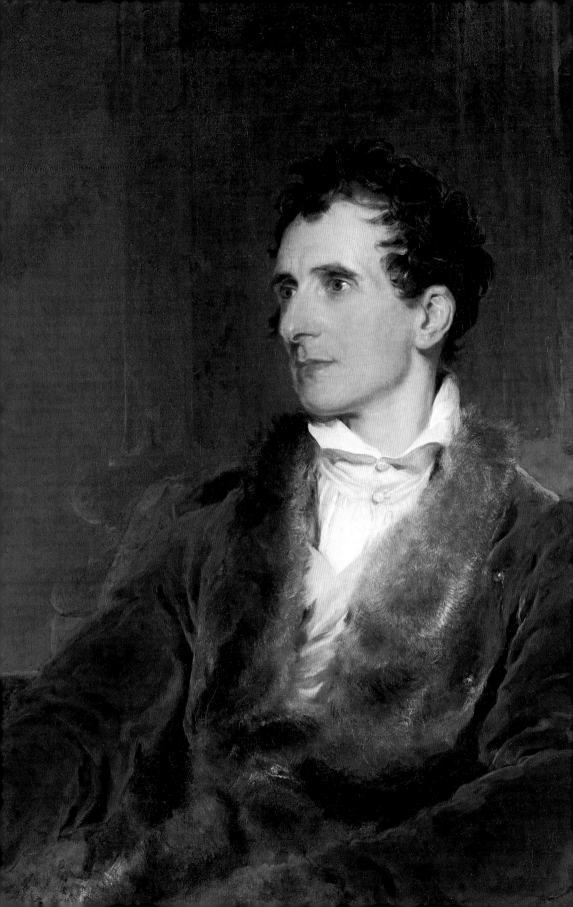

ANTONIO CANOVA IN THE VENETO
A Guide

by
ELENA CATRA and VITTORIO PAJUSCO
foreword by
VITTORIO SGARBI

Marsilio Arte

Acknowledgements
Pierangelo Amorelli
Ferdinando Businaro
Marcello Cavarzan
Maichol Clemente
Monica De Vincenti
Elisabetta Gastaldi
Simone Guerriero
Barbara Guidi
Padre Hamazasp
Tommaso Maggiolo
Silvia Marchiori
Paola Marini
Moira Mascotto
Stefania Portinari
Alberto Signor
Francesca Veronese
Lino Zanesco
Fabio Zonta

The general layout of the text and its subdivision is the
work of the authors.
In particular, Elena Catra drafted the texts on the
following pages
9–13, 21, 24, 25, 27, 32, 33, 34, 35, 36, 37, 38, 39, 40, 42,
43, 44, 45, 46, 47, 48, 49, 53, 54, 55, 71, 73, 80, 82, 84,
87, 94, 98–99, 100, 102, 104, 108,
and Vittorio Pajusco wrote the texts on pages
15–16, 57, 58, 60, 62, 63, 64, 65, 66, 69, 75, 76, 77, 78,
79, 88, 90, 92, 96, 97.
The following pages are co-written
50, 74, 122.

Graphic design
Studio grafico Bosi srl
Layout
Laura Ribul
Translations
Richard Sadleir
Copy-editing
Lemuel Caution
Maps
Veronica Simionato

*Iconographic research
and editorial coordination*
Alice Montagnin

© 2022 Marsilio Editori® s.p.a. in Venezia
first edition: July 2022
ISBN 9791254630587

www.marsilioeditori.it

On the cover: Antonio Canova, *Daedalus and Icarus*,
1777–1779, marble, Venice, Museo Correr.

p. IV: Thomas Lawrence, *Portrait of Antonio Canova*,
1815, Possagno, Museo Gypsotheca Antonio Canova.

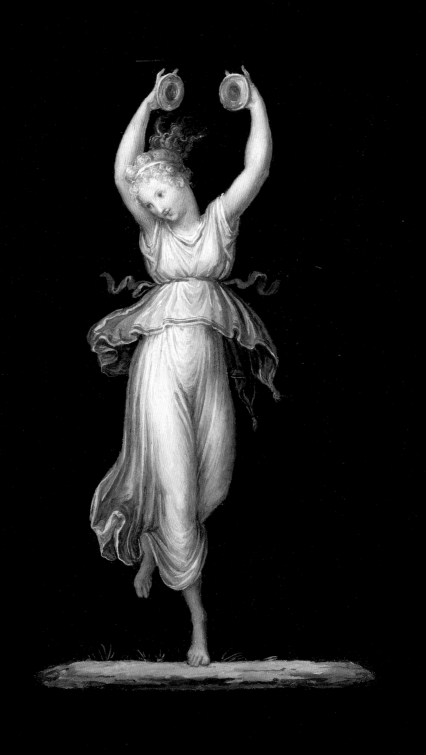

The consolation of travel

VITTORIO SGARBI
President of the Comitato Nazionale per le celebrazioni del bicentenario della morte di Antonio Canova
President of the Fondazione Canova Onlus of Possagno

Elena Catra and Vittorio Pajusco, two young and gifted scholars, have put together this valuable book, a manual for the uninitiated, suggesting one of the profound journeys that the Veneto offers of its numerous itineraries devoted to the discovery of the works of an Artist. It would not be possible for Gentile da Fabriano or Raphael in the Marches, nor Leonardo in Tuscany. In the Veneto it is feasible, however, for Palladio, Jacopo Bassano, the Marinalis and Carlo Scarpa, but not for Giorgione and not even for Titian. Certainly, and now with a useful guide such as this one, on Canova.

At the same time, the Veneto region proposes yet another attractive and original initiative: to establish, in the year of Canova's celebrations, a link and path between the houses of life and work of the greatest Venetian artists. Curiosity, sensibility, the spirit of people, and individual taste prompt one to travel to the homes of artists. Those who go to see Giorgione's house in Castelfranco Veneto will also want to see Canova's in Possagno, and will find Titian's energy at Pieve di Cadore. These three towns have established a connection that embodies and enhances the Veneto's identity. In the case of Canova, who had the providential insight, pursued by his brother Giovanni Battista Sartori, to associate a museum of his whole *oeuvre* with his home, the situation appears even more favourable, from his birthplace, Possagno, right up to that of his burial, Possagno. Beginning and end coincide, in the spaces of the Museo Gypsotheca, between 1757 and 1822, and the passionate traveller can, after imagining him in the long years of his wanderings in the world, find Canova in his rooms in the Veneto, in particular in Venice. The Canova itineraries include Bassano del Grappa, Crespano del Grappa, Padua, Vicenza, Altivole, Verona, Asolo, and Pagnano d'Asolo, some of the most poetic and evocative places of the Veneto mainland. Asolo, Altivole: Queen Catherine Cornaro.

Canova felt the Veneto to be his homeland, and he breathed in its landscape, just as Mantegna and Palladio did with Rome. The Pantheon transferred to Possagno is the demonstration of this, crowning the landscapes of the Camera degli Sposi and La Rotonda.

There was no other homeland: "I see the whole of Italy, indeed the whole of Europe, so ruinous that if I were not held back by so many things that chain me here, I would be tempted to go to America, because I feel I'm dying because of our poor state that I love so much," he wrote to Falier in 1797, after the Napoleonic invasion. And when, summoned by Napoleon to France, the emperor pressed him to stay, his overly strong bond with Italy, with

Dancer with Cymbals, 1779, tempera on paper,
Possagno, Museo Gypsotheca Antonio Canova.

Rome, with the Veneto, led him to return, writing in 1802 to his friend Antonio D'Este: "Do not believe that I will remain here, because I would not stay for all the gold in the world. I see too clearly that my freedom, my peace of mind, my studies, my friends are worth more than all these honours." This statement by one who remained humble and preferred to stay in Italy, living his own life, rather than being honoured and admired in France, is striking.

In the itineraries you will will be offered, solitary, in the beautiful rooms of the town hall of Asolo, is the immaculate *Paris*. From the model, preserved in the Museum Correr in Venice, four marble sculptures were derived. Two were still in Canova's studio when he died, waiting to be finished. The first was completed by an assistant and sold to Charles William Steward, Marquis of Londonderry, in 1826–1827; the second was donated by his brother, in 1836, to the municipality of Asolo, "in memory of that Canova, whom in earlier days the town made one of its citizens". A visit full of devotion, before entering the cathedral for the two versions of the *Assumption of the Virgin* by Lorenzo Lotto and Jacopo Bassano. The paths intersect.

In Bassano del Grappa, with many of Canova's relics, the rare sketch of *The Three Graces* is a precious and curious testimony to the artist's most intimate and secret moment, acquired by right of pre-emption from a Turin antiquarian, and coming from the heirs of the sculptors Fantacchiotti, having earlier belonged to the Abbot Melchiorre Missirini, a friend of Canova's. The sketch was conceived by Canova for Joséphine de Beauharnais, Napoleon's wife, as the first concept of the marble at the Hermitage in St Petersburg (a second version, commissioned by the Duke of Bedford, is in London at the Victoria and Albert Museum). Pure poetry.

In Padua we will meet the statue of Giovanni Poleni in Prato della Valle, the supreme place of pilgrimage in the Veneto. It was commissioned by Leonardo Venier to honour his teacher at the University of Padua, a distinguished Venetian mathematician, physicist and engineer. Canova began working on the statue in 1779, but broke off for his impending trip to Rome.

In Padua, still in its original place in Palazzo Papafava, are the *Perseus Triumphant*, the boxer *Kreugas* and *Hebe*. In Rome in 1817, Francesco Papafava bought from Canova the *Borghese Gladiator* and the *Apollo Belvedere*, to "accompany" Canova's plaster casts that his brother Alessandro had purchased eleven years earlier. This established a comparison, in the ballroom of the palazzo, between classical and neoclassical, between ancient and modern. It is deeply moving to find the sculptures in the niches where they were placed.

In Venice, in addition to Canova's incunabula at the Museo Correr, not to be missed are the relics at the Accademia, including the porphyry urn that contained the hand of Canova, mocked in the famous "epitaph" by Roberto Longhi: Antonio Canova, "the sculptor who was born dead, whose heart lies in the Frari, whose hand is in the Accademia and the rest I don't know where." But the curious visitor should be told that the two colossal statues of *Hector* and *Ajax*, from his studio in Rome, have been placed in the formal spaces of Palazzo Treves De' Bonfili*, where Leopoldo Cicognara, Canova's

friend from Ferrara and president of Venice's Accademia di Belle Arti, wanted them placed after Canova's death.. Cicognara suggested the purchase to Baron Jacopo Treves De' Bonfili, who agreed, partly for the sake of social prestige. They were sent to Venice in January 1827, and Treves adapted the grand hall of his palazzo on the Grand Canal to accommodate the sculptures. The design of the room was entrusted to Giuseppe Borsato, who interpreted Canova's instructions for correct viewing in zenithal lighting, with the pedestal fitted with a pivot (so that the sculpture could be turned 360 degrees). The prestige of Palazzo Treves De' Bonfili derives from the uniqueness of the grand hall, which became an obligatory sight on the travels of emperors and famous people, and on great occasions. Such as this one.

* Private residence, not open to visitors.

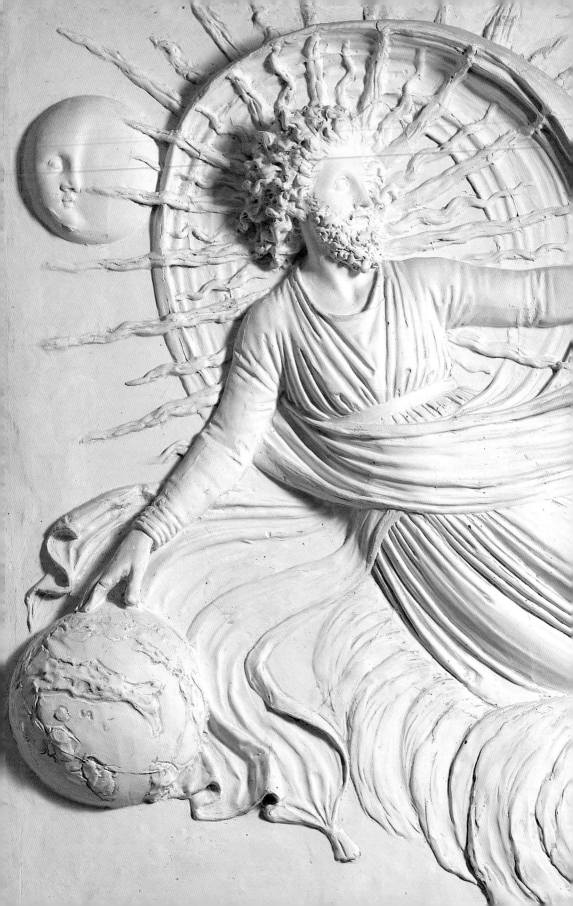

Antonio Canova and the "beloved homeland"

ELENA CATRA

In 1768 Canova left his native town Possagno (TV) for the first time, to settle first at Pagnano d'Asolo, a hamlet in the municipality of Asolo (TV), and then in Venice. Here in 1779 he won first prize for sculpture at the fair of Sensa and with the money earned went to Rome where he settled. While living and working in Rome, Canova always remembered his homeland and his fellow villagers (as they remembered him), and he never forgot the Republic of Venice.

Between 1779 and 1822 Canova returned to the Veneto several times, both for political or cultural events and personal reasons. On the death of his grandfather Pasino in 1794 and his grandmother the following year, Canova entrusted the birthplace and other properties to his aunt Caterina. In 1773 the sculptor, still in Venice, returned to Possagno to work on the statue of *Eurydice*. He returned again in 1792 to rest from his labours in Rome on the *Monument to Pope Rezzonico*. Canova also undertook a trip to Possagno in 1795, after inaugurating the *Monument to Angelo Emo* in Venice and in 1798, when the French occupied Rome. In these as in subsequent years, Canova remained in contact with most of the artists and nobles who had known him in his formative years and those of his early successes. In 1795 the Venetians, to thank him for the creation of the *Emo Monument,* coined a medal in his honour and presented it to him with this dedication: "To you, honorary citizen of Italy and of our homeland." In 1797, while the war was being fought across the peninsula leading to the French occupation of Rome and the fall of Venice, Canova expressed his feelings in some letters, the first to Giuseppe Falier, writing: "I have been working in marble on other things, because if I had had not had or kept my mind always busied in such matters I do not know whether I could have borne the sorrowful circumstances that are devouring the whole world. I'm so sensitive that when I think about it at night I'm unable to sleep any more." He wrote to Falier on 28 March: "I see the whole of Italy, indeed the whole of Europe, so ruinous that if I were not held back by so many things that chain me here, I would be tempted to go to America, because I feel I'm dying because of our poor state that I love so much." And to Selva on 20 April he wrote: "I leave it to you to imagine how deeply I am afflicted by the horrible misfortunes that are increasing daily in our desolate nation. Then, having to remain eight days together always in total uncertainty, this is another sorrow added to my heart and all the more so because (as you can well believe) my forebodings of every kind are growing. On these occasions, my dear friend, no one can be a philosopher, unless they are insane and lacking all reason. What happens is what Providence thinks most fitting. I would be very happy to gladly lose

1. *The Creation of the World*, 1821–1822, detail.
Metope for the Tempio di Possagno.

everything, indeed life itself, as long as I could in such a way benefit my adorable homeland, for such I will call it as long as I have a scrap of breath in me." These letters reveal Canova's affection for his homeland and show that in these circumstances, although he had thought of escaping to a foreign land, he remained attached to his own country and decided to find a little peace in his native town of Possagno. There he meditated on the events taking place, clarifying his ideas and conducting the first studies that would lead a few years later to the creation of the *Monument to Alfieri*.

The year 1798 was wholly devoted to a journey through Germany and Austria, and in 1799, the year of his withdrawal to Possagno, Canova meditated on the historical period and transformed his reflections into his work. In 1799 he devoted himself at various times to the great canvas of the *Lamentation Over the Dead Christ*, in which Mary Magdalene (related to the figure of *Temperance* on the *Monument to Pope Clement XIV*) is one of his first and most successful representations of the grieving woman meditating sorrowfully on the death of the Saviour. The message of the work, first focused on mourning and then on the political situation in those years, was subsequently given a different value due to the changes that Canova made particularly in 1810 and in the summer of 1821, which shifted the emphasis

2. *Lamentation over the Dead Christ*, 1799–1821, detail. Possagno, Tempio.

to the religious content. Highly significant, however, is the dedication at the bottom of the altarpiece bearing the words: "IN TOKEN OF LOVE FOR THE HOMELAND / ANTONIO CANOVA PAINTED / POSSAGNO 1799" (fig. 2, Possagno, Tempio). During his stay in the city, Canova had time to meditate on a project commissioned by the Venetians that spring: to erect a funerary monument to honour Francesco Pesaro, a Venetian patrician who had died in March 1799. After opposing Bonaparte, on the fall of the Serenissima he had taken refuge in Vienna in 1797 and then returned to Venice two years later as commissar extraordinary of the Habsburg Empire. The monument was commissioned from Canova by Giuseppe Priuli and a group of Venetian patricians, many of whom were Canova's friends, as Francesco Pesaro himself (to whom Tadini had dedicated his monograph on Canova) had once been. After a first refusal by the sculptor, Priuli went personally to Possagno to persuade

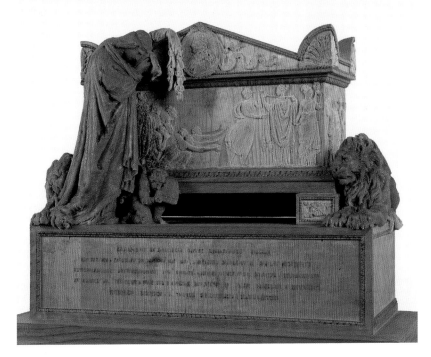

3. Model of the Funerary *Monument in Honour of Francesco Pesaro*, 1799–1802. Venice, Museo Correr.

Canova, who immediately set to work. Of this monumental project, never completed, there remains a model in wax and wood (fig. 3 Venice, Museo Correr). It enables us to recognize the concept underlying the composition, in which the personification of Venice appears "dressed in a majestic pallium with a long train. She rests her left arm on the urn and from her hand hang some rich garlands of flowers offered to the ashes of her beloved son; and with her right hand lifting the hem of the same pallium, and bowing her head, she wipes away her tears." In 1802, when news arrived from Venice that the project had been set aside, Canova responded: "great sorrow in observing that my adorable homeland was so lukewarm in protecting and animating the fine arts and allows this project vanish as well as the other for *Titian*." The patriotic image of Venice in tears would soon be used by Canova as an image of Italy mourning at the tomb of Alfieri.

Returning to Rome in the autumn of 1799, he continued to meditate on the theme of the lamentation over the dead Christ and in 1801 completed the *Perseus Triumphant* (Vatican, Vatican Museums). Together with *Napoleon Bonaparte as Mars the Peacemaker* and *Theseus Vanquishing the Centaur*, it had been commissioned by the Italian Republic to embellish Milan as its capital. All three works, as we know, ended up in very different places.

In 1802 Pope Pius VII appointed Canova inspector general of Antiquities and Fine Arts of the State of the Church, promulgating one of the first laws prohibiting the export of artworks from the Papal States and banning unauthorized excavations. From this year on, having become famous throughout Europe, Canova became a promoter and defender of Italian arts and artists.

In 1804 Canova received the commission from the Bourbon king Louis of Etruria to make a marble copy of the *Venus de' Medici*, formerly in the Uffizi and taken to Paris in 1802. Instead of a copy he persuaded his client to accept a *Venus* of his own invention, hence modern. It was intended to replace the ancient work on the pedestal left empty, in a strong affirmation of national pride, stressed by the adjective in its title as the *Venus Italica*. The same had happened with the *Perseus*, by which he had compensated the Vatican Museums for the loss of the *Apollo Belvedere*.

In 1809 Canova was contacted by his fellow citizens to contribute to the expenses for some necessary repairs to the old parish church of the village. As a result, he conceived the idea of building a new church at his own expense. After being disappointed by the rejection of a planned monumental statue of *Religion*, which he wished to donate to St Peter's Basilica, then to the Pantheon, in 1818 Canova decided to use the large sum of money set aside for his most important architectural project, the church in his village.

In 1819 Canova finally returned to Possagno for the laying of the first stone of the Tempio Canoviano he had designed. The "new Phidias", a few years before his death, wished to equal the ancients in piety for religion and his homeland. In addition to the architecture, Canova also conceived the sculptural decorations: a frieze of twenty-seven metopes inscribed with episodes from the Old and New Testaments, but managed to complete only seven in the state of plaster models. Particularly interesting, with regard to our theme, is the metope depicting the *Creation of the World* (fig. ANTIPORTA). It represents "the author of nature at the centre of creation, when turning his gaze towards the shining planet he seems to command it to make the earth fruitful and irradiate it with its splendour. Obediently, the planet seems to project itself into the immensity of space, drawing its gleaming hair behind it, reverberating from its luminous centre the very image of its creator. The divine arms seem to touch the extremes, as if assigning the distance of their prescribed orbits to the planets in the celestial hemisphere." The terrestrial globe is made fruitful and irradiated with divine splendour, but everything is concentrated on the Italian peninsula alone that occupies the whole globe, as if to say that all of God's power and beauty has been concentrated in only one part of the world: the Italian Republic of the Arts.

4. The Tempio di Possagno.

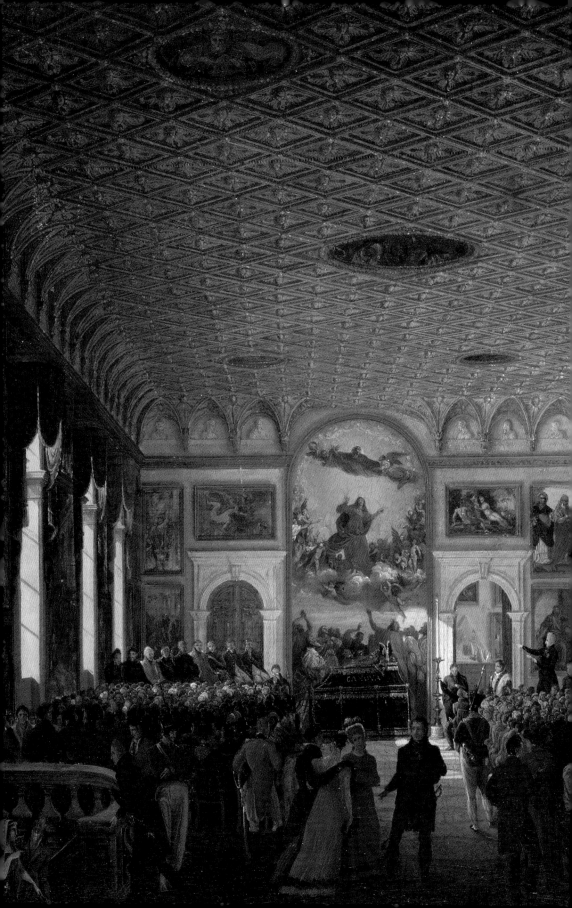

After Canova, sculpture in Venice between the nineteenth and twentieth centuries

VITTORIO PAJUSCO

Antonio Canova died in Venice on 13 October 1822. His funeral was held on 16 October in St Mark's Basilica and from there the coffin was borne in procession to the Regia Accademia di Belle Arti, where it was placed in the large upper chamber of the former Scuola Grande di Santa Maria della Carità, beneath Titian's *Assumption*. The scene was recorded by Giuseppe Borsato in a famous painting (fig. 1).

Titian and Canova are the two most successful Venetian artists of all time, with princes, popes and emperors vying for their services.

In academic teaching, Titian's *Assumption of the Virgin* was the culmination of pictorial art to which every artist aspired, the greatest example of the Venetian Renaissance style, and for this reason studied and copied by many painters from all over the world. In the same way, Canova's sculptures became the canon of the new art of statuary in his lifetime.

Canova's public funeral and the display of his body beneath the work of Titian celebrated the greatness of Venetian art while it decreed the end of a world still associated with the Ancien Régime. Canova, who was born and had lived in the last century of the Serenissima, saw Venice pass from French to Austrian rule. With the creation of the Kingdom of Lombardy-Venetia, the Austrian viceroys also established the political and cultural supremacy of Milan over Venice. Increasingly impoverished, Venice became on the one hand a Romantic myth and on the other an open-air market for foreigners interested in acquiring precious souvenirs. The city's Accademia di Belle Arti, which was also subordinated to the Accademia di Brera in Milan, therefore needed the myth of Canova to revive its fame. Leopoldo Cicognara, its director, organized this final celebration of Canova and promoted the Monument in the Basilica of Santa Maria Gloriosa dei Frari (the church so dear to Titian), which would soon become one of the city's most frequently visited places.

Who were the Venetian sculptors who would perpetuate Canova's achievement after 1822? A few years before, Luigi Zandomeneghi (1779–1850) had been appointed teacher of sculpture at the Accademia in Venice. Zandomeneghi devoted himself body and soul to teaching the students (those he favoured included Innocenzo Fraccaroli and Antonio Giaccalli), whom he often employed on his monumental works. In the city you can admire *The Angel of the Campanile of San Marco*, the *Stele Commemorating Carlo Goldoni* at the entrance to the Teatro La Fenice and the two reliefs on the facade of the church of San Maurizio. After Luigi Zandomeneghi's death, Luigi Ferrari (1810–1894) won the competition for the chair of sculpture. Art ran in the family, his father being the sculptor Bartolomeo Ferrari (1780–1844),

1. Giuseppe Borsato, *Commemoration of Canova* (detail), 1824, Venice, Galleria Internazionale d'Arte Moderna di Ca' Pesaro.

in turn the nephew of Canova's first teacher Giovanni Ferrari called Torretto (1744–1826). Luigi Ferrari, who in the early 1850s completed the great and celebrated marble of the *Laocoön* (Brescia, Pinacoteca Tosio Martinengo), created the sculptural group of *Doge Francesco Foscari and the Lion of St Mark*, among other works, over the Porta della Carta of the Doge's Palace in Venice. He trained generations of sculptors and was director of the Accademia until his death in 1894.

In the second half of the century, in art and literature, the Romantic and realistic spirit was preferred to the Neoclassical. The Risorgimento provided good opportunities for work for sculptors, especially in extolling the fathers of the homeland, creating busts and statues that were placed in squares or public buildings. Works in this strand in Venice included the series of illustrious men in the *Panteon Veneto* for the Doge's Palace (today in the Istituto Veneto, Palazzo Loredan), the *Monument to Daniele Manin* by Luigi Borro of Ceneda (1826–1880) and the one to Carlo Goldoni by Antonio Dal Zotto (1841–1918).

The Venetian Dal Zotto entered the Accademia when he was only 12 years old and practically never left. From being a promising student he became a teacher of sculpture and anatomy and finally, after Ferrari's death, he was appointed its director. A rare portrait painted by the American Charles Frederic Ulrich (*The Sculptor Antonio Dal Zotto in His Studio*, c. 1883, Baltimore, Museum of Art) shows the sculptor working in his studio on a sketch model of the monument to Goldoni. However, if you look carefully behind him, on the shelves at the centre of the composition, you can see a miniature plaster of Canova's *Daedalus and Icarus* beside Verrocchio's Colleoni monument. In the later nineteenth century, Canova was still the model, the essential example from which to start, like the masters of the Italian Renaissance.

In 1895 Venice changed: the Biennale was founded, a series of great international art exhibitions that would bring together local and Italian masters as well as great foreign artists. The museum of the Biennale in Venice is the Galleria Internazionale d'Arte Moderna, housed since 1902 in the grandiose Baroque palazzo of Ca' Pesaro on the Grand Canal. Among the collections in this museum the names of two sculptors are outstanding: Auguste Rodin (1840–1917), the artificer of great French monuments, and the Lombard Medardo Rosso (1858–1928). The latter became famous in Paris in the late nineteenth century, contrasting Rodin's Michelangeloism with small sculptures, apparently insignificant, depicting the faces of children or women. Rosso's rapid modelling ignored the plane of the definitive in the attempt to capture effects of imprecise delicacy through the interaction with light. His intimate, fragmentary and anti-heroic sculpture would be the basis for all European avant-garde art. The use of wax as the principal material in his work recalled a century later, the famous "last touch" that Antonio Canova gave to marble works to bring softness and warmth to the cold marble.

2. Giuseppe Borsato, *Leopoldo Cicognara Illustrates the Monument to Canova at the Frari*, 1828, Paris, Musée Marmottan Monet.

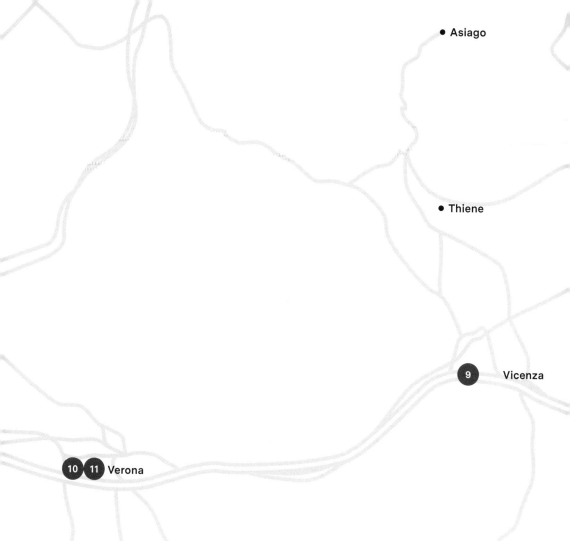

Asiago

Thiene

9 Vicenza

10 11 Verona

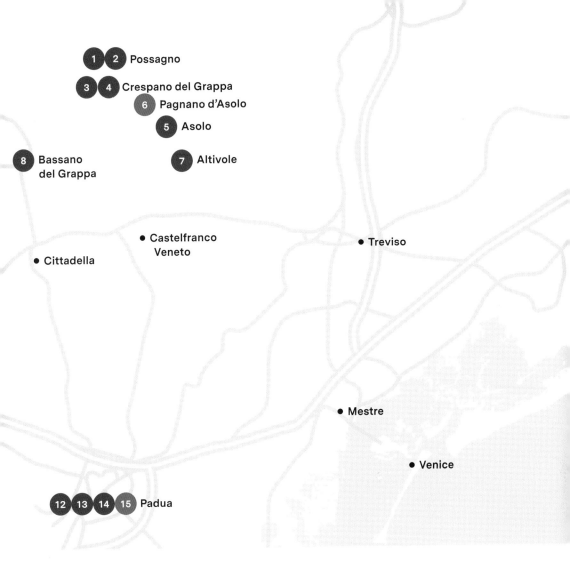

Map locations:
1 2 Possagno
3 4 Crespano del Grappa
6 Pagnano d'Asolo
5 Asolo
8 Bassano del Grappa
7 Altivole
Castelfranco Veneto
Cittadella
Treviso
Mestre
Venice
12 13 14 15 Padua

 works places

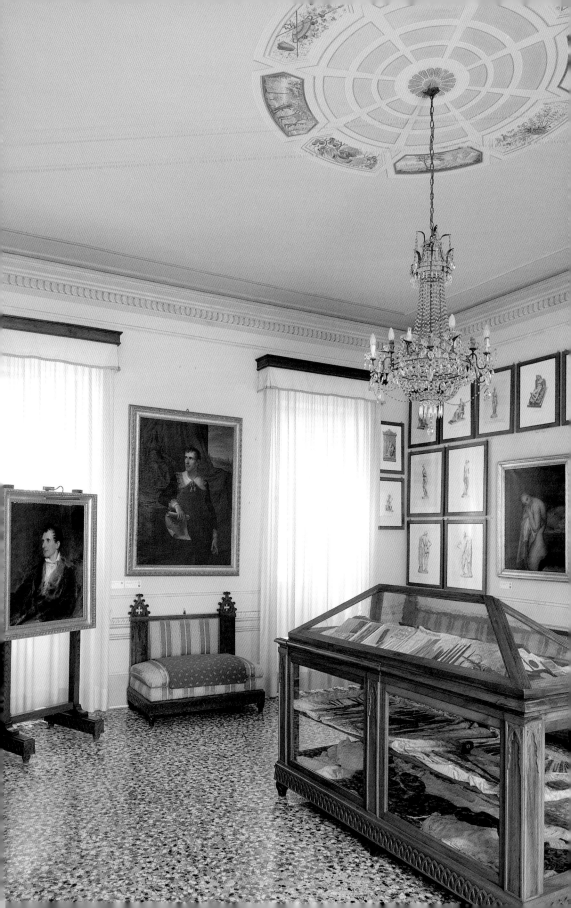

Possagno (TREVISO)

Antonio Canova was born at Possagno (TV) on 1 November 1757. The most significant memories of the sculptor's life are preserved in his native village, including the house where he was born, the Gypsotheca built at the behest of his brother Giovanni Battista Sartori and the Tempio Canoviano, the greatest testimony to Canova's love of religion and Possagno. The whole of the artist's estate, accumulated during his career through the sale of statues to the world's most important and wealthiest men and women, was lavished on the building of the Tempio. EC

 Museo Gypsotheca Antonio Canova
The birthplace

The house where Antonio Canova was born displays objects associated with his everyday life (spectacles, clothes, a wig...), his tools (drill, chisels, hammers, rasps, gouges, points, etc.), the principal medals and honours he received, his study in the Torretta or turret, the garden with the orchard and the large maritime pine he planted, the spacious park, Roman relics, the stables and the portico. The house contains a very fine collection of paintings on canvas and a series of temperas by the artist. EC

Room where Canova was born (detail)
in Casa Canova, Possagno, Museo Gypsotheca
Antonio Canova.

Following pages: La Torretta (detail) interior
of Casa Canova, Possagno,
Museo Gypsotheca Antonio Canova.

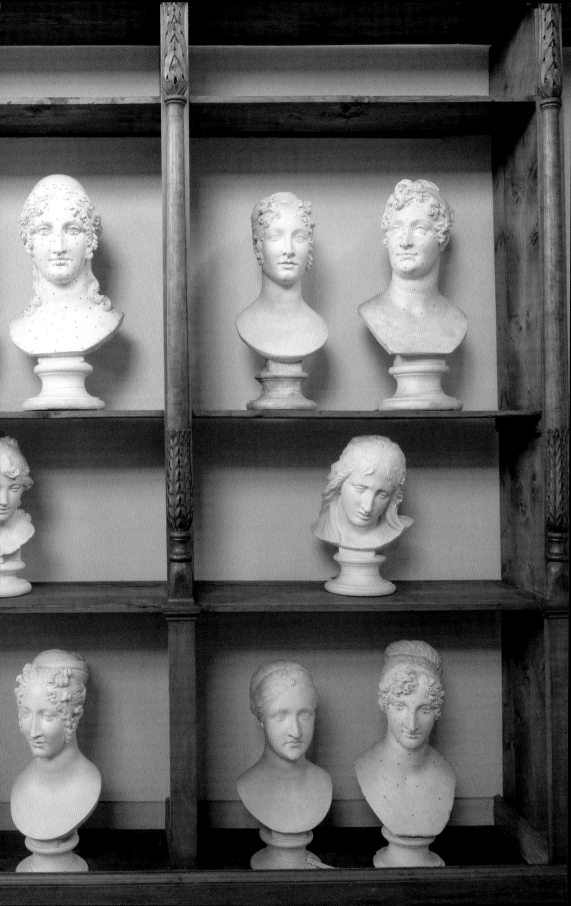

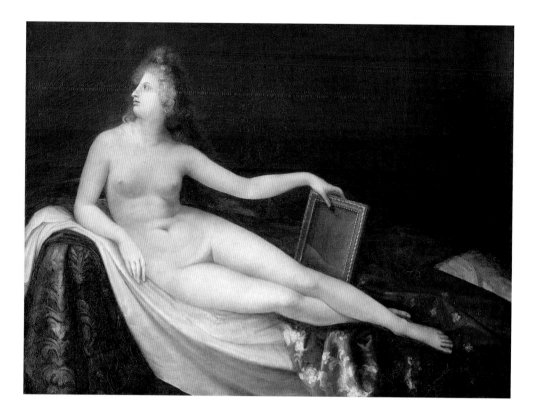

• *Venus with a Mirror*

1787, oil on canvas

Canova, although absorbed by his work as a sculptor, also devoted himself to painting. He began in Rome and increased his output of paintings during his stay at Possagno (TV) between 1798 and 1799. Being unable to work on sculpture there, except for some clay sketch models, he turned to painting, but had to do without priming. On several occasions, he remarked on the fact that he painted "for his own pleasure". He would make known the works he considered worthy of attention wherever appropriate and have them reproduced as prints. In Venice in 1792, at the home of the Cavaliere Girolamo Zulian, one of his patrons, he exhibited "a painting representing a Venus [...] that surprised everyone by its accomplished beauty". It was *Venus with a Mirror*, which contemporaries compared to Titian's *Venus* and the grace of works by Correggio. In Canova's creative process painting was an essential form of study

for his future sculptural works. See, for instance, the painting of *The Surprise* that anticipated the *Venus Italica*; the *Venus with a Faun* that anticipated *Pauline Bonaparte as Venus Victrix* and the painting of *The Graces* that anticipated the sculptural group of the same name. EC

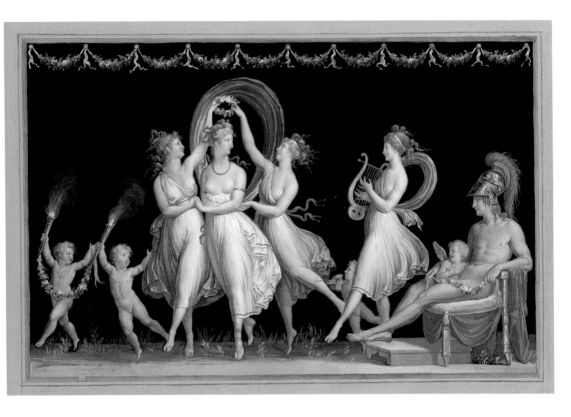

• *Venus and the Graces Dancing Before Mars*

1797, tempera on paper

In Canova's house there are 34 temperas on paper with a black ground, described as "various ideas for dances and the playing of Nymphs with cupids, Muses and Philosophers, etc., intended solely for the artist's study and pleasure". They grew out of his interest in the paintings found in Pompeii and Herculaneum. The temperas are divided thematically into *The Muses with Greek Philosophers and Writers*, *Nymphs with Cupids* and *Dancers*, and were produced in the late eighteenth and early nineteenth century. As with the paintings, some subjects of the temperas also became sculptures: the *Dancer with Her Hands on her Hips*, the *Dancer with Cymbals* and the *Dancer With Finger on Chin*. The 34 temperas are similar in size, with the exception of the larger *Market for Cupids*, which consists of several sheets. Recently scholars have conjectured that, to create these works, Canova drew on the assistance of other artists, just as he used

assistants to rough out his works in marble. The tempera of *Venus and the Graces Dancing Before Mars* depicts Venus with her gaze turned to Mars as she dances with the three Graces, two holding a wreath of flowers above her head and another playing the lyre. Canova gave an original interpretation to the ancient theme of Venus as peacemaker, soothing the god of war with her beauty. The tempera corresponds to a plaster bas-relief placed in the nineteenth-century wing of the Gypsotheca. EC

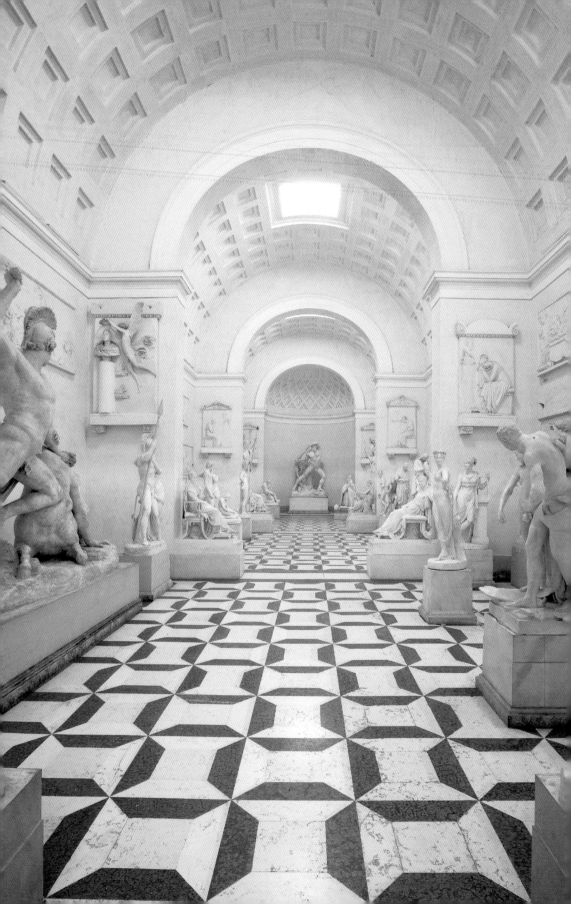

Giovanni Battista Sartori stated in a letter of 1834 that the impressive gallery of Canova's works was his last tribute to the honoured memory of his beloved brother. If the Tempio was the great gift that Canova wished to leave to his birthplace and his fellow villagers, the Gypsotheca was the great gift left by Giovanni Battista to Possagno (TV). Visiting the Gypsotheca (the word comes from Greek and means a collection of works in plaster) offers the visitor the opportunity to see in one place all the original models and plaster casts of works in marble that Canova sent to many parts of the world, today to be found in the most important museums and collections. On Canova's death, his brother Giovanni Battista decided to pack all the contents of his studio in Via delle Colonnette in Rome (the building still exists), and send them to Possagno. It was an extraordinary journey. The works were dismantled and placed piece by piece in a hundred crates. Their transfer took two voyages by sea from Rome to Mestre (VE), and from there by land to Possagno. The Gypsotheca was built next to the birthplace and was completed in 1836 to a project by the Venetian architect Francesco Lazzari, but it was not until 1844 that the statues were recomposed and could be displayed on specially made pedestals (many of which can rotate). One of the criteria used for the placing of the works was to separate profane from sacred subjects, with the latter displayed in a privileged position. The original exhibition layout was changed for the first time in 1947, when the works in plaster from the Gallerie dell'Accademia arrived from Venice and a few years later, in 1957, when the extension designed by Carlo Scarpa was officially opened.

In contemporary times the museum suffered considerable damage from shelling in World War I. Many works that we admire today were severely damaged and then restored. The museum officially reopened during the first centenary of the sculptor's death in 1922. Later, during World War II, the museum closed and became one of the repositories for the protection of Venetian artworks. On 30 May 1948, the Gypsotheca reopened to the public after being closed for almost six years, with the collection expanded and displayed in the same spaces, which were becoming increasingly cramped. On the Canovian anniversary of 1957 it was decided to give new scope to the works with an extension to the existing premises. The structure was designed by the Venetian architect Carlo Scarpa in a way that forms a marked contrast to the original edifice. EC

The Lazzari Wing, Possagno, Museo Gypsotheca Antonio Canova.

Following pages: The Scarpa Wing, Possagno, Museo Gypsotheca Antonio Canova.

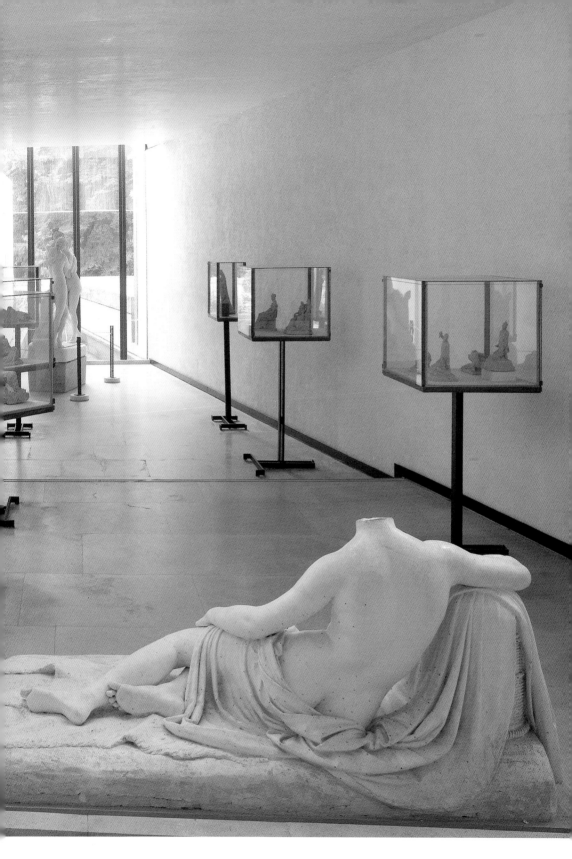

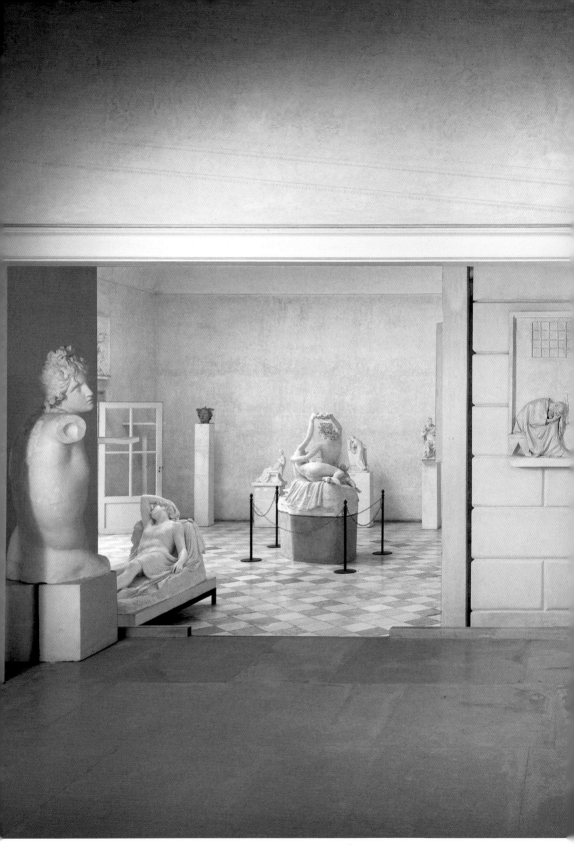

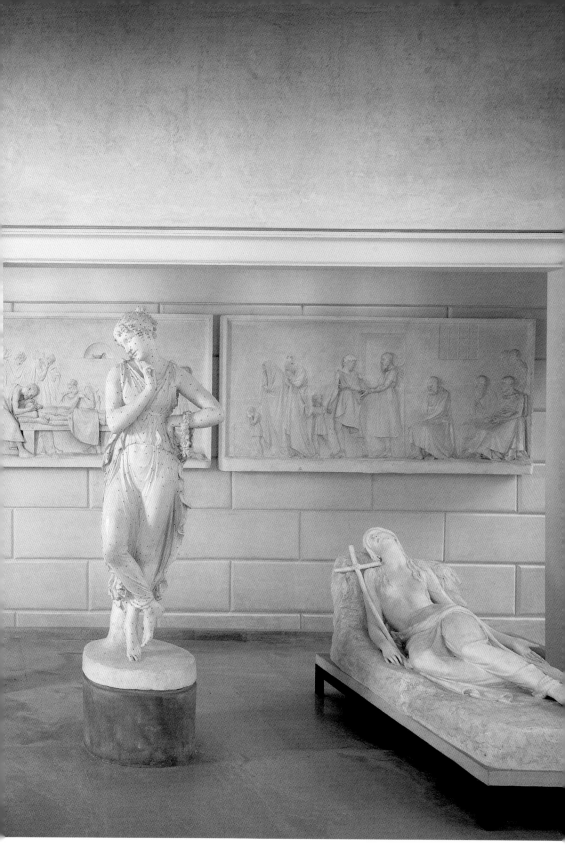

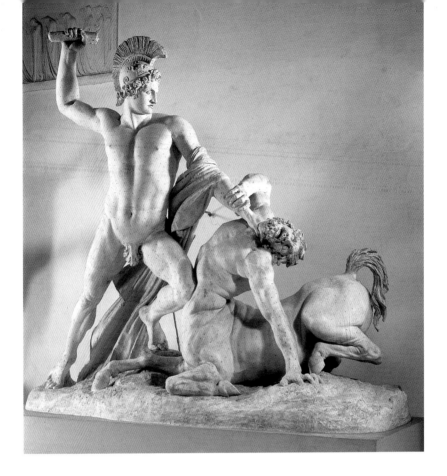

• *Theseus and the Centaur*

1804–1805, plaster model

The work was commissioned by the Italian Republic to be placed in the Foro Bonaparte in Milan. Together with the *Hercules and Lichas* (Rome, Galleria Nazionale d'Arte Moderna), it is one of the sculptor's colossal groups, by which he put his skills to the test in dealing with the heroic theme. In the case of the *Theseus*, the message lay in the triumph of valour over brute force, represented by the monstrous creature. It shows Theseus as he is about to slay the Centaur who, while attending the wedding of Hippodamia, together with his companions became intoxicated with wine and attempted to abduct the bride and other women present at the feast. Theseus intervened to save them. Canova, with extreme naturalness, captures the extraordinary sense of movement that pervades the work. The hero's powerful leg is wedged against the Centaur's belly. The extreme naturalness of the human body of the Centaur was derived from study of the face and torso of the *Laocoön* in the Vatican Museums, while the twisting of his horse's body was studied from a real dying horse. The dimensions of the sculpture required 15 years' work. When it was completed in 1819, it was purchased by the Emperor Franz Joseph I of Austria, who had admired it in Canova's studio. It was intended for a small temple in the gardens of the Hofburg in Vienna. In the late nineteenth century it was moved to the newly inaugurated Kunsthistorisches Museum and placed triumphantly at the top of the monumental staircase at the entrance. Despite its prominent position, the work loses much of its dynamism by being set against a wall, preventing it from being viewed in the round, as Canova intended. The model was donated by Giovanni Battista Sartori to the Accademia di Belle Arti in Venice in 1824 and in 1947 it was deposited at Possagno (TV). EC

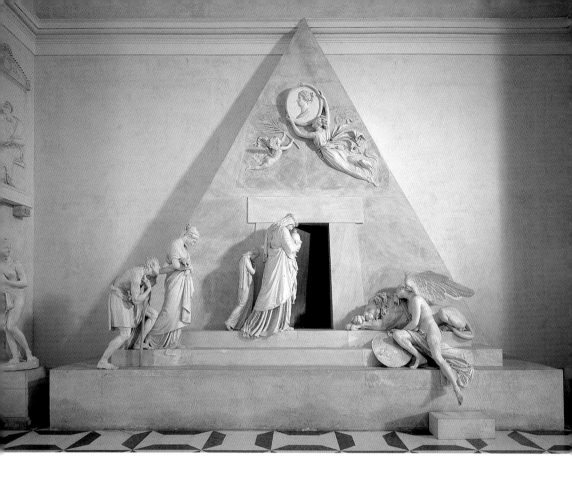

• *Funerary Monument to Maria Christina of Austria*

1800, plaster model

Albert von Sachsen-Teschen commissioned Canova to create the work in August 1798, when he went to Vienna to persuade the imperial authorities to resume payment of his annuity. The work commemorates the death of the Archduchess Maria Christina of Habsburg-Lorraine. The wife of Albert von Sachsen-Teschen, she had died a few months earlier. Returning to Possagno (TV), Canova immediately set to work on the conception of the monument. He used the general structure of the *Monument to Titian* commissioned a few years earlier for the Basilica of Santa Maria Gloriosa dei Frari in Venice and never completed. In the *Funerary Monument to Maria Christina of Austria*, the predominant impression is not of the archduchess in her earthly identity, but a secular reflection on the themes of death, eternity, celebration and mourning for the deceased. The pyramid, the doorway (symbolizing the threshold between life and death) and the grieving figures arranged in procession become the central

elements of the work, rich in significance. The epitaph and the image of the deceased, framed by the uroborus (the symbol of a snake biting its tail) and supported by Felicity, are the only elements that recall the archduchess. On the right side of the monument there is a reclining lion, in a melancholy pose, representing Fortitude, with the emblems of the archduchess beside it, and a Genius, representing Prince Albert. After the marble was finished, Canova went to Vienna in the summer of 1805 to supervise the assembly of the sculptures in the Augustinerkirche. In the plaster model at Possagno, the pyramidal structure is the work of Carlo Scarpa, while it lacks some of the details found in the marble, such as the maiden who precedes Virtue, the drapery on the steps and the garlands.

The *Funerary Monument to Maria Christina of Austria* served as a model for the *Funerary Monument to Antonio Canova* in the Basilica of Santa Maria Gloriosa dei Frari in Venice. EC

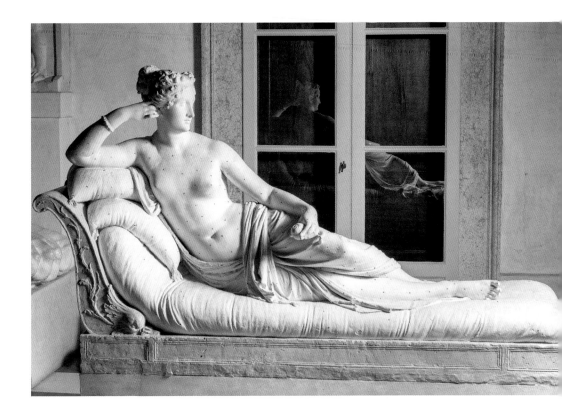

• *Pauline Bonaparte as Venus Victrix*

1804, plaster model

In 1804 Canova was commissioned to sculpt the effigy of Pauline Bonaparte by her husband, Prince Camillo Borghese. Having discarded his initial idea of representing Pauline in the guise of Diana (the chaste goddess who disdained men), Camillo and Pauline decided that the princess should be represented as the goddess of beauty, Venus, reclining on a sumptuous divan, half-naked. In her left hand she displays the apple of victory awarded her by Paris in the celebrated competition on Mount Ida between the three principal female deities of Olympus, in which the goddesses Minerva and Juno were defeated. When the work was finished in 1808, it was transferred to Turin, where Camillo had been appointed governor general of the transalpine departments. On the fall of the empire, in 1814, the marble was shipped by sea to Rome, but seized by Napoleon on Elba and finally reached Palazzo Borghese in Rome. The princess, who was very beautiful as well as famous for her free and easy manners and disregard of conventions, was barely clothed in the statue, causing such a stir in puritanical Rome that the emissaries of the pope asked Camillo to prevent its display. Sources of the time recount that "crowds hurried to admire it, unable to be satisfied with idolizing it by day, they also longed to see it in the evening by torchlight to better admire its beauty and the gradations of the flesh tones, so that a stop had to be put to these excesses". The work was later moved to Villa Borghese, where it is still exhibited today. EC

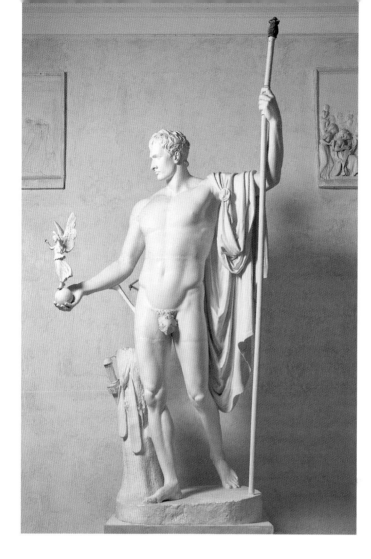

• *Napoleon Bonaparte as Mars the Peacemaker*

1806, plaster cast

In September 1802 Canova was invited to Paris to make a portrait of Napoleon. During his stay Napoleon asked the sculptor for a marble statue representing him. The marble work was completed in August 1806. It was subsequently exhibited in the artist's studio and received general applause. The work shows Napoleon standing naked with his left arm raised holding a staff and his right hand outstretched holding a globe of copper gilt and surmounted by a winged Victory. The military chlamys is draped over his shoulder. By his side a tree trunk serves as a support. The work was placed aboard ship in 1810 to be sent to Paris, with orders to sink it in the event of an attack by the Royal Navy. The statue reached Paris early in 1811, where it was exhibited at the Louvre and seen by Napoleon. He judged it indecorous because of its nudity and had it covered. When Napoleon fell in 1816, the marble was purchased by the British Government and given to the Duke of Wellington, the victor of Waterloo, to be placed in Apsley House, his London residence, where it is still today. The fame of the sculpture prompted the viceroy of Italy Eugène de Beauharnais to ask Canova for a bronze copy for the city of Milan in 1807. The bronze was made by Francesco Righetti in 1809 and in 1813 it was placed in Brera. After Napoleon's downfall, it was removed and put in storage, only being taken out again in 1859. EC

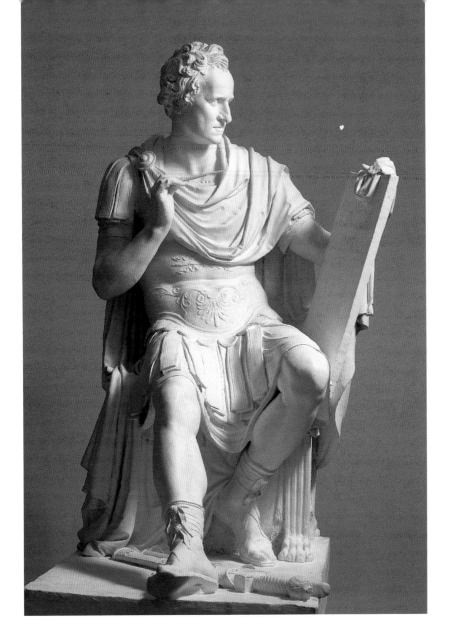

• George Washington

1818, plaster cast

In 1816 the State of North Carolina commissioned a commemorative statue of George Washington from Canova. Thomas Appleton, the American consul in Livorno, wrote to the sculptor on behalf of the American President Thomas Jefferson, who had suggested Canova's name to the representatives of North Carolina. The work was completed and shipped to the United States in 1821. The marble was unfortunately destroyed in a fire that devastated the building in 1831, leaving only a few fragments of the sculpture. A record of it is the plaster cast preserved in the Gypsotheca at Possagno, which represents President Washington seated, in heroic guise wearing the lorica (cuirass) and cloak, in keeping with the ancient Roman models of the Caesars and generals. He is shown signing the letter by which he renounced power. At his feet lie the staff of command and the sword. EC

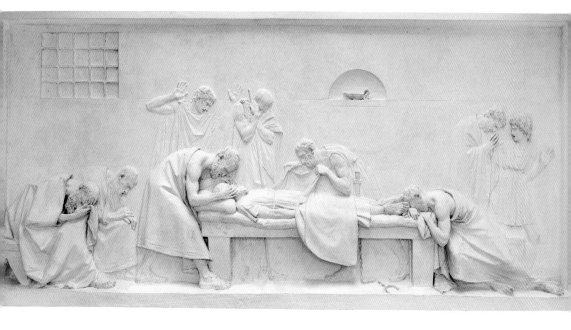

• *Crito Closing the Eyes of Socrates*

1790–1792, plaster

One of the unique exhibits in the Gypsotheca of Possagno is the complete series of plaster bas-reliefs made by Canova during his career. They number more than 15 works, produced at different times, without commissions and not intended to be executed in marble. Unlike marble, the bas-relief allowed the sculptor to insert numerous figures in the same work and study the different expressions of their feelings and poses. The works were intended for personal use or for people particularly close to the sculptor (there were bas-reliefs in the Paduan collection of Girolamo Zulian, in that of Prince Abbondio Rezzonico in his villa at Bassano del Grappa, in Palazzo Barisan in Castelfranco Veneto (TV), in the Venetian collection of the procurator Antonio Cappello, in the collections of Bernardino Renier, the architect Giannantonio Selva, Giuseppe Giacomo Vivante Albrizzi and Senator Giovanni Falier). Due to lack of space, in the museum these works are placed too high up to be appreciated in detail. An exception is the series devoted to the death of Socrates, selected by Carlo Scarpa to be set at eye level in the 1957 extension. The four bas-reliefs (*Socrates Takes His Leave of his Family, Socrates' Final Speech, Socrates Drinks the Hemlock; Crito Closes the Eyes of Socrates*) are taken from Plato's Phaedo. The moral and dramatic intensity of Socrates' death was represented by Canova in a restrained style with archaic colouring, revealing not only his study of ancient sculpture but also Cinquecento works, in particular those of Donatello and Tullio Lombardo.

An important series of Canova's bas-reliefs can be admired at the Museo Correr in Venice (the museum has some bas-reliefs on deposit at the Gallerie dell'Accademia and at Palazzo Ferro Fini, the seat of the Veneto Regional Council). EC

• Cupid and Psyche

1797, plaster model

The work was inspired by the ancient marble of *Cupid and Psyche* preserved in the Capitoline Museums of Rome. In that work, however, the two figures are represented in the act of kissing. Here the composition is wholly embodied in the delicate relationship between the two figures united in an embrace, brought out in Cupid's head bowed on Psyche's shoulder. There is an extraordinary interplay of glances focused on the rhythmic gesture of the hands holding and protecting the butterfly. This detail becomes the centre of the work. The butterfly symbolizes the spiritual love that has its seat in the soul. In ancient times the soul (*psyche*) was represented by a butterfly. The formal resolution adopted by Canova heightens the work's significance and brings out the pure ideal of that heavenly love.

Canova produced two versions of this work, now in the Louvre in Paris and at the Hermitage in Saint Petersburg. These collections also contain the two versions of the famous group of *Cupid and Psyche* embracing. The plaster model of this is not present at Possagno (TV), because the sculptor gave it to one of his assistants, Adamo Tadolini. It is now on display at the Metropolitan Museum in New York. EC

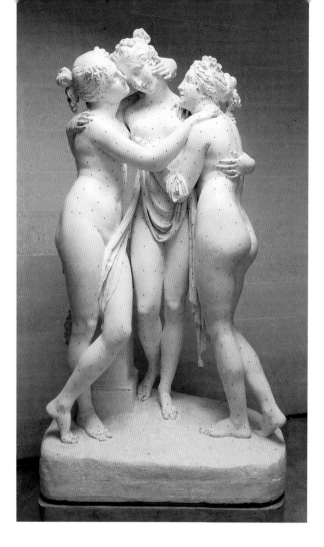

• *The Graces*

1813, plaster model

Canova had previously represented the theme of *The Graces* in works on canvas, in tempera, in some bas-reliefs, in monochromes and in a terracotta. He returned to the subject in 1813 at the explicit request of the former Empress Joséphine de Beauharnais, a great admirer of Canova, who in her collection already possessed four of the sculptor's masterpieces: *Hebe*, the *Dancer with Her Hands on her Hips*, *Paris* and *Cupid and Psyche* (standing version). Canova here depicted the Graces (Aglaia, Thalia and Euphrosyne), representing all three for the first time frontally. The group, indebted to ancient iconography, personifies the theme of personal qualities, such as beauty of sentiment, kindness and friendship, represented by female nudes embracing affectionately with delicate gestures, languid looks and almost whispered words. To commemorate the success of the work, Canova instituted three annual dowries to be given to three young women of Possagno, poor and of good morals, to enable them to marry. During work on the plaster model, John Russell, the sixth Duke of Bedford, visited Canova's studio and asked for a second version, which Canova made for him with some changes. The most evident is the altar, concealed at the feet of the figure at left, which was replaced by a column (a cast of it is in the nineteenth-century wing of the Gypsotheca). Joséphine's marble, together with her whole collection, is now in the Hermitage in Saint Petersburg, while since 1994 the marble made for John Russell is owned jointly by the Victoria and Albert Museum in London and the National Gallery of Scotland in Edinburgh. EC

• *Concord with the Graces*

c. 1809, terracotta

In 1809 Elisa Bonaparte Baciocchi (Ajaccio 1777–Trieste 1820), Grand Duchess of Tuscany (1807–1814), commissioned a life-size sculptural portrait of herself as *Concord*. The terracotta model is one of the studies preserved at Possagno (TV) that testify to Canova's creative technique. Cicognara recalls in the biography of the artist that Canova, after fixing "his thought on paper, [...] began the various trials,

sketching it in clay or wax in small proportions, until, having found the favourable moment to reproduce and fix the composition of the subject in these sketches, he then formed the large model, studied with all the perfection that art suggested to him". The *Concord*, without the Graces, was later sculpted in marble in the likeness of Marie Louise of Habsburg-Lorraine (Parma, Galleria Nazionale). EC

ANTONIO CANOVA'S WORKING METHOD

In 1779 Antonio Canova arrived in Rome, where he began to study ancient statuary and the technique of execution. He also began to observe both the French sculptors who studied at the Academy of France, and the Roman restorers–copyists Bartolomeo Cavaceppi and Carlo Albacini. Through these sculptors, active in Rome, Canova devised his own practice, organizing it as an orderly sequence of separate phases, some of which he entrusted to helpers. He would begin a sculpture by making a clay maquette to fix his first intuition (anticipated by drawings and sometimes paintings). Later, he changed to a plaster model that allowed him a fuller study of the invention. This was followed by the creation of a clay model, of the same size as the final work, supported with an iron framework branching out into small metal rods fitted at the ends with wooden crosses. However, clay had the disadvantage of drying unevenly depending on the thickness, so

progressively altering the original proportions. The transition from the clay model to a plaster one was made with the lost form technique. The modelled clay, covered with a fine layer of reddish plaster, subdivided by sheet metal into multiple valves, was covered with a layer of white plaster. The valves were opened to remove the clay and closed to cast the plaster inside the mould. This would then be carefully destroyed to reveal the reddish plaster, which would in turn be eliminated to free the white plaster model. This would then be covered with the *repères* or points (hundreds of nails applied to specific points of the work's whole surface). After pointing up the model, his assistants would use the appropriate implements (plumb lines frames, and also, in the last years of Canova's activity, a pantograph) to transpose the measurements to rough out of the marble, leaving a small layer more than on the plaster model. This allowed Canova to sculpt the final layer and so complete the work. EC

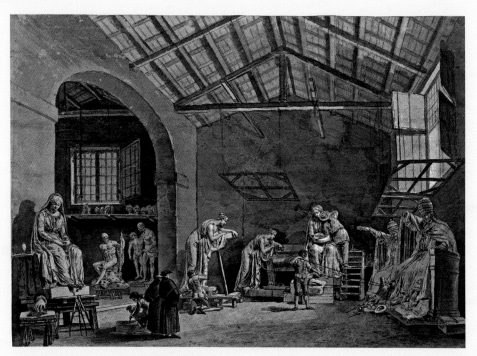

Francesco Chiarottini, *Antonio Canova's Studio in Rome*, c. 1785, drawing in pen, grey and brown ink, grey and brown watercolours, blue paper, Udine, Civici Musei, Gabinetto disegni e stampe del Castello.

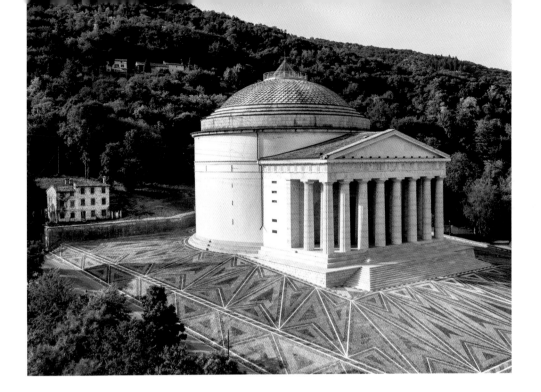

2 The Tempio Canoviano

Opposite the Museo Gypsotheca Antonio Canova, a flight of steps and a drive lead to the Tempio. Its parvis, built with stones from the Piave River, is the work of the architect Giuseppe Segusini of Feltre (1801–1876). In 1809 Canova was contacted by his fellow citizens to contribute to the necessary repairs to the old parish church of the village (which no longer exists). As a result, the sculptor, after careful reflection, expressed his wish to build a new church at his own expense. It would be paid for with the savings he had allocated to the construction of the monumental statue of *Religion* for St Peter's Basilica, a project that was rejected.

Canova designed the church in 1818. The building consists of three parts: a Doric colonnade (a double row of eight columns each recalling the Parthenon of Athens), the central body of cylindrical shape, similar to the Pantheon in Rome, and the apse in an elevated position as in the ancient Christian basilicas. The three parts represent the three ages of human history: Greek civilization, Latin civilization and Christianity.

On 11 July 1819 Canova was in Possagno (TV) for the laying of the first stone of the Tempio. From then on, at least once a year Canova returned to Possagno to inspect the building work.

The Tempio, consecrated by his brother Giovanni Battista in 1832, is the parish church of the village and dedicated to the Trinity, as the Latin inscription on the pediment declares: "DEO OPT MAX UNI AC TRINO" (to God most excellent and almighty, one and three). The interior contains Canova's tomb as well as important works by him and other artists.

From inside the Tempio it is possible to climb up to the top of the dome, which offers fine views across the surrounding landscape. EC

• Metopes

The Creation of the World, The Creation of Man, The Fratricide of Cain,
The Sacrifice of Isaac, The Annunciation,
The Visitation and *The Purification of the Virgin Mary*

1821–1822 [interior], plaster
1824 [on the facade], Istrian stone

A metope is an architectural frieze used in the decoration of Doric temples, consisting of a sculpted panel that usually depicts a figure or tells a story. For the Tempio, Canova designed 32 but managed to model only seven of them. (The works in plaster are kept inside the Tempio above the doors of the side chapels; other series are located under the portico of the Museo Gypsotheca and at the Gallerie dell'Accademia in Venice.) The sculptor wanted the final stone version to be placed on the pediment of the Tempio, to be sculpted by seven promising young sculptors associated with him and the Accademia di Belle Arti in Venice. Those chosen were Antonio Bosa, Bartolomeo and Gaetano Ferrari, Andrea Monticelli, Angelo Soavi, Giacomo De Martini and Luigi Zandomeneghi. (Some of them were also commissioned to create the *Monument to Antonio Canova* in the Basilica of Santa Maria Gloriosa dei Frari.) The cycle was completed by sculpting 25 ornamental metopes.
The metopes, created to be inserted into the entablature of the Temple, are linked by a coherent compositional and iconographic theme, representing fundamental episodes of the Old and New Testaments, namely *The Creation of the World*, *The Creation of Man*, *The Fratricide of Cain*, *The Sacrifice of Isaac*, *The Annunciation*, *The Visitation* and *The Purification of the Virgin Mary*. The metopes on the pediment should be read from right to left. The first is *The Creation of the World* and the last is *The Purification of the Virgin Mary*. EC

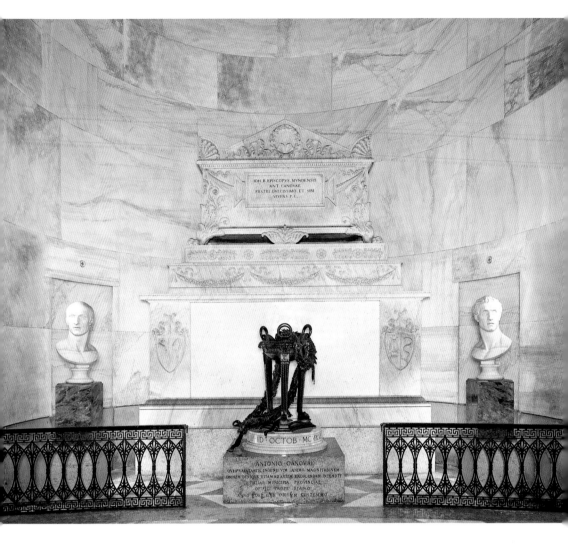

• *Tomb of Antonio Canova* (formerly the *Funerary Monument to Marquis Berio*)

1822, marble

Antonio Canova died suddenly in Venice on 13 October 1822. His will named his brother Giovanni Battista his universal heir. The coffin was transported to Possagno (TV) and temporarily placed in the old church of the village pending completion of the Tempio Canoviano. Giovanni Battista oversaw the construction of the tomb of Canova in the Tempio. He decided that the most suitable monument to preserve his remains for eternity should be something created by Canova himself and decided to reuse one that was in the studio in Rome. He took the *Tomb of the Marquis Berio* of Naples, which the family had failed to pay for and have delivered, and stripped it of the elements referring to the Berio

family, such as the coats of arms and the great bas-relief that portrayed the deceased and his whole family (the plaster and marble are in the Museo Gypsotheca). The space of the bas-relief remains empty, while on the right was placed the coat of arms of the marquisate of Antonio Canova (a snake and a lyre in homage to his first work *Orpheus and Eurydice*) and on the left, in 1858, was added the coat of arms of the bishopric of Giovanni Battista, when he was also buried in the tomb. The rest of the work remained as Canova had conceived it: a large sarcophagus with the inscription "JOH.B. EPISCOPUS. MYNDENSIS. ANT. CANOVAE. FRATRI. DULCISSIMO. ET. SIBI. VIVENS.PC." resting on a base adorned with garlands. EC

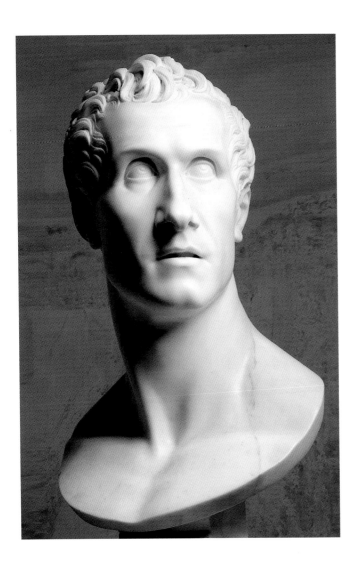

• Self-Portrait

1812, marble

The work was created in 1812 following numerous requests from his friends, who asked him to portray himself in marble. Canova accepted the challenge and produced this portrait of himself with his face turned slightly to one side. Although he had lost most of his hair at an early age, the sculptor represented himself with one of the many wigs he used to wear on official occasions (one is diplayed in a showcase in the birth room at Casa Canova). He is shown with his hair worn in the fashion of the time, in what was termed the "windblown" or "guillotine" hairstyle, with curly hair combed forward as if blown by the wind. His lips are parted and his head slightly turned as if someone had just spoken to him and he was responding. This would become the official image of the artist, with numerous marbles and casts being made after this marble work. EC

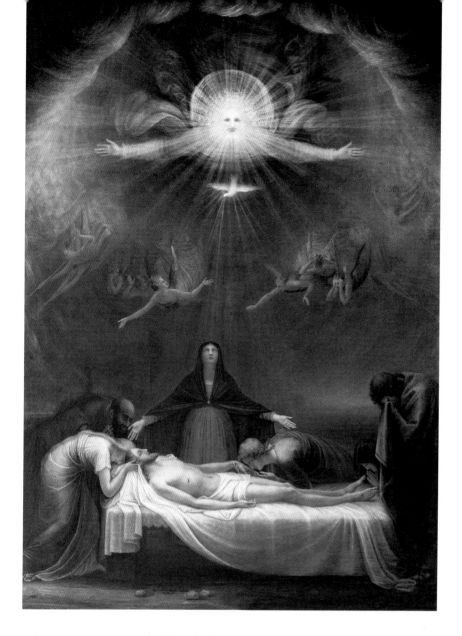

• *Lamentation over the Dead Christ*

1799–1821, oil on canvas

In 1798 Canova took refuge at Possagno (TV) after the French occupation of the Papal States. During this enforced stay, which lasted into the following year, he worked on the *Lamentation over the Dead Christ*, developing a personal and moving interpretation of the theme. The large canvas depicts the Virgin praying with her arms outstretched over the body of the Saviour surrounded by Mary Magdalene, John the disciple, Joseph of Arimathea and Nicodemus, who covers his face with his cloak. The work was retouched by the artist first in 1810 and then in the summer of 1821, with a view to placing it in the Tempio then being built. At the bottom right is the inscription: "IN TOKEN OF ATTACHMENT FOR THE HOMELAND / ANTONIO CANOVA PAINTED / POSSAGNO 1799." In 1800 the sculptor created a bas-relief with the same theme (Possagno, Town Hall, Council Hall) and later the group of the *Pietà*. EC

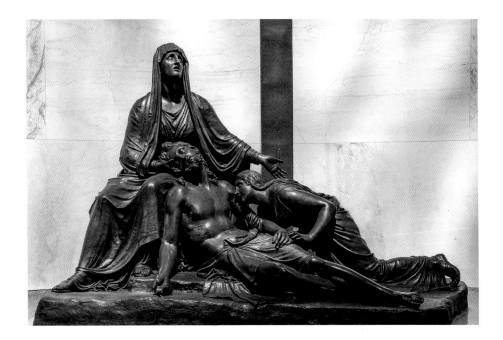

• Bartolomeo Ferrari (after Antonio Canova), *Pietà*

1830, bronze

In the spring and summer of 1815 Canova was in Paris as the ambassador of the Papal States, working to return to Italy the masterpieces of art that Napoleon had pillaged on his military campaigns. On this occasion his friend Antoine Chrysostome Quatremère De Quincy urged him to make a sculpture of the *Pietà*. Canova had already explored this theme in painting with the *Lamentation over the Dead Christ* that he made at Possagno (TV) for the parish church of his village and in 1800 with the bas-relief of the same subject. He set to work on a clay model in September 1821 (Venice, Gallerie dell'Accademia). The plaster model (Museo Gypsotheca), consisting of life-size figures of the Virgin, the dead Christ and Mary Magdalene, was completed in early November as shown by the words scored on it 'COMPLETED IN NOVEMBER 1821', and successfully exhibited in his studio in Rome. Being busy with other works, Canova was unable to work up the model in marble before he died. Giovanni Battista Sartori decided to commission the Bolognese sculptor Cincinnato Baruzzi to make a marble version of it. In 1826 Sartori changed his mind in favour of a bronze casting of the *Pietà* to be placed in the Tempio then being completed at Possagno. This work was entrusted to Bartolomeo Ferrari (1780–1844), a Venetian sculptor and founder, who had already worked on one of the seven metopes intended for the decoration of the Tempio and had recently finished the statue personifying *Sculpture* for the *Monument to Antonio Canova* in the Basilica of Santa Maria Gloriosa dei Frari. The plaster model arrived in Venice in 1827, was cast in bronze in 1830, and in the same year placed in the right-hand niche of the Tempio Canoviano at Possagno. EC

Crespano del Grappa
(HAMLET NEAR PIEVE DEL GRAPPA, TREVISO)

Canova is associated with Crespano del Grappa (in the municipality of Pieve del Grappa) through his mother Angela Zardo. Angela was born at Crespano on 3 May 1737 into a family well-known in the village that could boast a long tradition of craftsmanship in the art of wood carving. The young Angela met her first husband, Pietro Canova, during the construction of the cathedral of Crespano. They were married on 23 November 1756 and three children were born to them, of whom only the first child, the famous Antonio, survived. After Pietro's death (1761), Angela entrusted Antonio to the care of his grandparents on his father's side at Possagno, and remarried (1762), her second husband being Francesco Sartori (?–1806) of Crespano. By her second marriage she had four children, only two of whom survived, Maria (1771) and Giovanni Battista (1775). Although living at a distance, Angela managed to keep on close terms with her son Antonio, who helped his stepbrother financially in his studies as a seminarian. Giovanni Battista became a priest and went to Rome (summer 1800) with his mother to visit his now famous brother Antonio and stayed there permanently in his service, while his mother returned to Crespano. Antonio and Giovanni Battista kept up a correspondence with their mother. The descendants of Antonio and Giovanni Battista still live in the village of Crespano and retain in their possession many works and memorials of both. EC

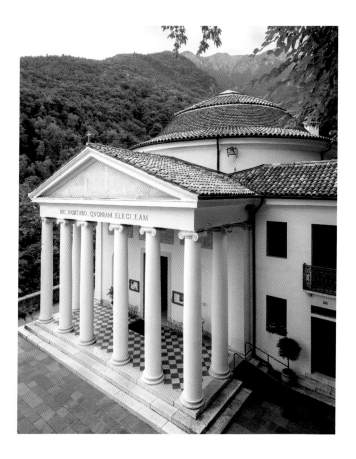

According to tradition, it was in this place at Crespano that the Virgin Mary appeared to a deaf-mute shepherdess and healed her. In the second half of the 1200s a first shrine was built and over the centuries it was the altered and enlarged. Antonio Canova, a member of the Confraternita della Beata Vergine del Covolo, designed the shrine in its current form. It was built between 1804 and 1809 by Giovanni Battista Zardo known as Fantolin, a cousin of Canova's. The building, inspired by the Pantheon, consists of a rotunda entered through an atrium enclosed by a peristyle of eight ionic columns. This building was the model for the Tempio Canoviano in Possagno, built by Fantolin, to whom Canova wrote: "The experience you had in building the rotunda of the Madonna del Covolo will be very useful in making it simpler to execute this [the Tempio in Possagno]." EC

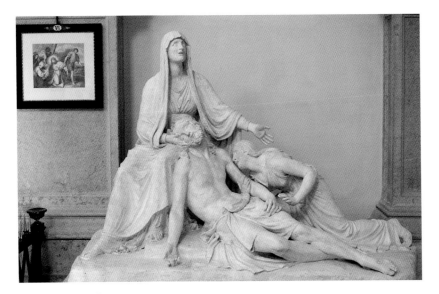

4 Cathedral of Crespano del Grappa
church of Santi Marco e Pancrazio

• *Pietà*

plaster cast, Crespano del Grappa, Cathedral

There is little documented information about the plaster cast of the *Pietà* by Canova that can now be seen in the right aisle of the cathedral. The original model with the metal points is in the Museo Gypsotheca at Possagno; the bronze cast by Bartolomeo Ferrari is in the Tempio Canoviano at Possagno; a plaster copy made by Ferrari is in the Gallerie dell'Accademia in Venice, while a second plaster copy "left by Monsignor Bishop Canova to Signor Ferrari" was given in 1839 to the charitable institution of the Asili di Carità per l'Infanzia in Venice to be sold at a charity auction. This plaster copy aroused the interest of Chancellor Klemens von Metternich, president of the Academy of Fine Arts in Vienna, who wished to enrich its collection of sculptures. A third plaster copy of the *Pietà* is at Crespano, but is undocumented, except in an 1833 guide that places it in the sacristy of the church. EC

GIOVANNI BATTISTA SARTORI

Giovanni Battista Sartori was born in 1775 at Crespano del Grappa, in the municipality of Pieve del Grappa (TV) to Francesco Sartori and Angela Zardo (a widow since 1761 of Antonio's father, Pietro Canova). Thanks to the generosity of his brother, Sartori was able to study at the Episcopal Seminary in Padua where he received an excellent classical education. He immediately proved a model student, becoming a skilled translator from Aramaic, a refined scholoar of ancient Greek and Latin and a great enthusiast for the art of oratory.

On 9 May 1800 Giovanni Battista moved to Rome to help his brother, who needed a cultural advisor. From this date he was always close to the artist, acting as his secretary and helping him run the studio. With a nuncupative will on 12 October 1822, Canova named him his universal heir. Giovanni Battista completed the Tempio Canoviano at Possagno begun in 1819 and he had his brother's works still in his studio in Rome taken to Possagno (TV), Canova's birthplace. There he had the Gypsotheca or Museum of Plaster Casts built to house them. In addition to Possagno, the Seminaries of Treviso and Padua also received important donations of items associated with Canova. The first was given his precious library of Greek classics, while to the Seminary in Padua he donated 3,593 Roman coins from the consular and early imperial periods. The Museo Civico of Bassano del Grappa (VI) received several artworks of notable value belonging to Canova's personal collections, numerous plaster busts, the models for equestrian statues of Charles III of Naples and Ferdinand I, hundreds of volumes from his personal library, the 12 volumes of Canova's correspondence and the collection of drawings, sketches and life studies comprising hundreds of sheets. Sartori was a generous and enlightened patron to his and his brother's homeland and to the places that had been closest to Canova and important in his cultural and religious development. In recognition of his works of piety and charity, Pope Leo XII in 1826 appointed Giovanni Battista titular bishop of Mindo (Turkey), a position that enabled him to personally consecrate the Tempio at Possagno in 1832.

Sartori asked to be buried in the precinct that encloses his brother's ashes. He died at Possagno in July 1858. EC, VP

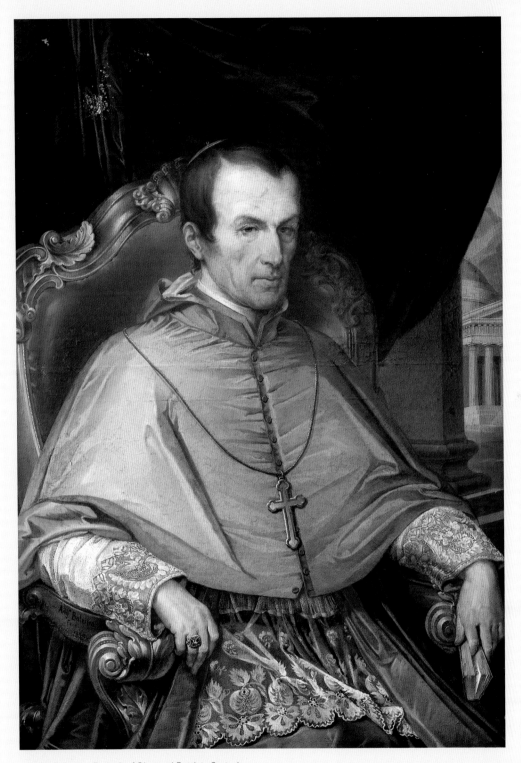

Angelo Balestra, *Portrait of Giovanni Battista Sartori*,
1859, oil on canvas, Possagno, Istituto Cavanis, on
deposit at the Museo Gypsotheca Antonio Canova.

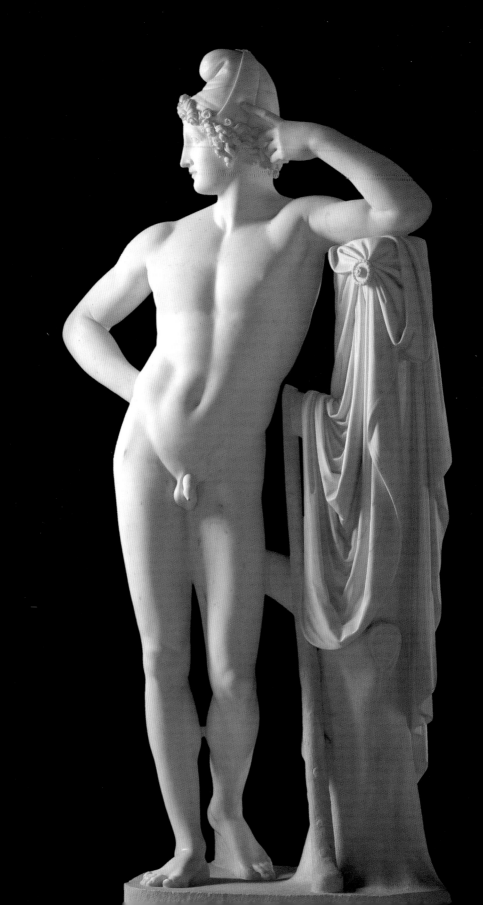

Asolo (TV)

 Museo Civico

The Museo Civico of Asolo contains the statue of *Paris,* donated in 1838 by Giovanni Battista Sartori, Canova's brother, together with other memorials of Canova from a bequest by Andrea Manera, the nephew of Domenico Manera (Asolo (TV) 1773–1825), a cousin and trusted assistant of Canova in Rome. In 1825 he gave the city a stele commemorating Canova, to be placed in the Council Chamber of the Town Hall. Manera's legacy consisted of two works in tempera (*Hebe* and *Euterpe*), a series of engravings on a black ground, a portrait of Canova, a watercolour by Roberto Roberti depicting the exterior of Canova's studio in Rome and a series of personal mementos of the artist (his tools, spectacles, a death mask, a letter…). EC

• *Paris*

1810–1816, marble

The work was commissioned by Joséphine de Beauharnais (1807–1812, Saint Petersburg, Hermitage) and replicated for Prince Ludwig I of Bavaria (1810–1816, Munich, Neue Pinakothek). From the model in the Museo Correr in Venice, four works in marble were made, two of them with blemishes. On Canova's death, these last were present in his studio, in the finishing phase. The first was completed by one of Canova's collaborators and sold to the Marquis of Londonderry between 1826 and 1827 (New York, Metropolitan Museum of Art), while the second was donated in 1836 to the municipality of Asolo (TV) with the following words: "In memory of that Canova, whom in earlier days the town had made one of its citizens." In the letter of donation Sartori specified: "A Paris in Carrara statuary marble of the first quality, semi-colossal, full-length, treated in the precise dimensions of the model by Canova, worked in Rome in his studio, so to speak before his eyes, and perhaps not wholly devoid of some of his caresses." The work was unveiled on 31 May 1838, in the Town Hall, where a niche was made specially for it and the base was constructed with a pivot inside it (still functioning today) to enable it to be rotated and admired from every angle. The statue of *Paris* was so successful that in observing it one of its greatest admirers stated: "The chisel that made that statue is the tool one least remembers in gazing at it; for if by caressing the marble you could make statues […] I would say that this statue was formed by wearing away the marble that surrounded it with caresses and kisses." The head of the statue of *Paris* was replicated by Canova to satisfy the requests of some clients, who could pair it with the famous *Head of Helen*. Casts of *Paris* are to be found in the Museo Gypsotheca in Possagno and the Gallerie dell'Accademia. EC

Pagnano d'Asolo (HAMLET IN THE MUNICIPALITY OF ASOLO (TV))

6 **Sacristy of the parish church**

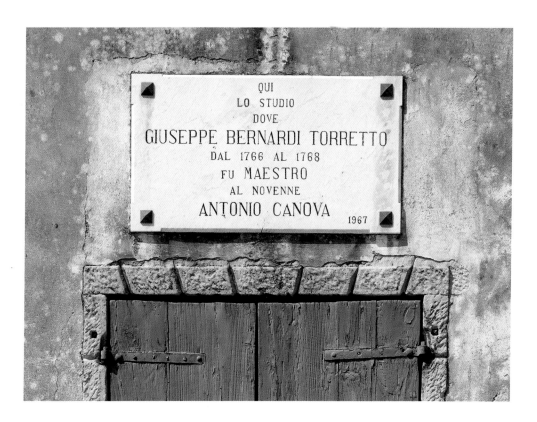

QUI
LO STUDIO
DOVE
GIUSEPPE BERNARDI TORRETTO
DAL 1766 AL 1768
FU MAESTRO
AL NOVENNE
ANTONIO CANOVA
1967

• Studio of the sculptor Giuseppe Bernardi called Torretto

The plaque was placed outside the sacristy in 1967. It records the young artist's apprenticeship in the studio of Giuseppe Bernardi (Pagnano d'Asolo (TV) 1694–Venice 1774). Bernardi lived mainly in Venice, but between 1766 and 1768 he returned to Pagnano d'Asolo (TV), his native village, to work on the statues at Villa Ca' Falier in Villa d'Asolo (formerly Pradazzi d'Asolo in the municipality of Asolo). On this occasion the young Canova, at the time only nine years old, was entrusted to his care. He continued to stay with Bernardi even after the latter's return to Venice. In 1768 Bernardi bought a house and land at Pagnano d'Asolo. In the autumn of 1769 he returned to Venice, where he died in 1774. On his master's death, Canova remained in the studio under Bernardi's nephew, Giovanni Ferrari (Crespano del Grappa (TV) 1744–Venice 1826). The church contains a number of masterpieces by Bernardi: *The Baptism of Jesus*; *Pietà* and *Sant'Anna*. EC

Altivole (TV)

 Parish church of San Vito e Compagni martiri

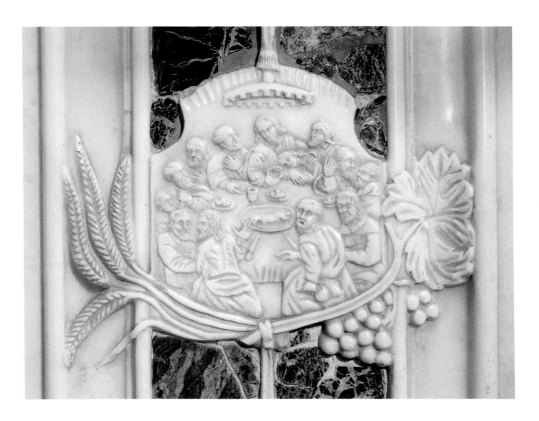

• *The Last Supper and the Eucharistic Symbols*

1769, marble
San Vito d'Altivole in the Mucipality of Altivole (TV)

Pasino Canova (1711–1794), Antonio's grandfather, was a prolific stonemason active in the foothills of Grappa. For example, he sculpted the *Angels* placed on the altar of the church of Monfumo (TV), the altar of the cathedral of Asolo (TV), and those of the churches of Crespano del Grappa, a hamlet in the municipality of Pieve del Grappa (TV), Thiene (VI) and Galliera Veneta (PD), etc. Antonio learned the art of the mallet and chisel from his grandfather, assisting him in his various commissions. In 1769 Pasino Canova fashioned the altar for the church of Altivole and the sources indicate that a very youthful Antonio, twelve years old at the time, delighted in creating the figurative decorations depicting the *Last Supper and Eucharistic Symbols*. EC

Bassano del Grappa (VI)

8 **Museo Civico**

After Antonio Canova's death, his brother Giovanni Battista Sartori was responsible for transferring the artworks and documents still in the artist's studio in Rome to Possagno (TV). In 1851, through the good offices of Canova's great-nephew, Pietro Stecchini, a donation was made to the municipality of Bassano del Grappa (VI). The city traversed by the Brenta River was the cultural centre closest to Possagno, which for years had had a library and a picture gallery, and was therefore the most suitable place to preserve and enhance the value of the writings and graphic works of the great Venetian sculptor.

Stecchini and Sartori considered the museum in Bassano an ideal place to store easily perishable materials: ten albums of drawings and eight sketchbooks; 6685 sheets including 698 autograph letters and 4081 letters received by the sculptor; a series of writings, a collection of engravings, some paintings from his collection, all the artist's personal documents, part of his rich library, as well as some sketches and various plaster casts. The casts were exhibited in the room of the museum designed to house the considerable heritage of Canovian materials. The construction of this new section of the museum is commemorated in a painting by Giacomo Casa from about 1850: *The Laying of the First Stone of the Sala Canova in the Museum of Bassano*. The Sala Canova was opened in 1853 and the marble bust of Abbot Sartori Canova made in 1852 by the Roman sculptor Pietro Tenerani was placed in the entrance. VP

• *Venus Italica*

c. 1812, plaster cast

In 1802 Canova was commissioned by the Bourbon King Louis of Etruria to make a marble copy of one of the most famous ancient sculptures formerly present in Florence and recently transferred to Paris, known as the *Venus de' Medici*. The sculptor decided to make not a copy but a statue of his invention to be named the *Venus Italica*. Canova did not want the modern Venus to be placed, as they wished to do in Florence, on the base that remained of the old one, but on a new one created by him, to stress that it was distinct from the ancient sculpture. The poet Ugo Foscolo extolled its originality, contrasting it with the ancient work, described as a "beautiful Goddess", while he termed Canova's Venus a "beautiful woman".

From the same model dating from 1804, Canova made three versions of the Venus emerging from the bath and seeking to conceal her nudity. The first was for the hereditary prince Ludwig I of Bavaria (Munich, Residenzmuseum), completed in 1810; the second – the most beautiful and famous – in 1811, named the *Venus Italica* (Florence, Palazzo Pitti), was placed in the Tribune of the Uffizi, in the place of the famous *Venus de' Medici* taken to Paris; and a third in 1814 for Lucien Bonaparte (San Simeon, Hearst San Simeon State Historical Monument). The evident success of this modern *Venus* led to the request for a fourth version for the English collector Thomas Hope (Leeds, Leeds Art Gallery). After a discussion in Rome in 1816 with the client, Canova decided to create a new *Venus* that would be very different in composition, attitude and details from the previous three. VP

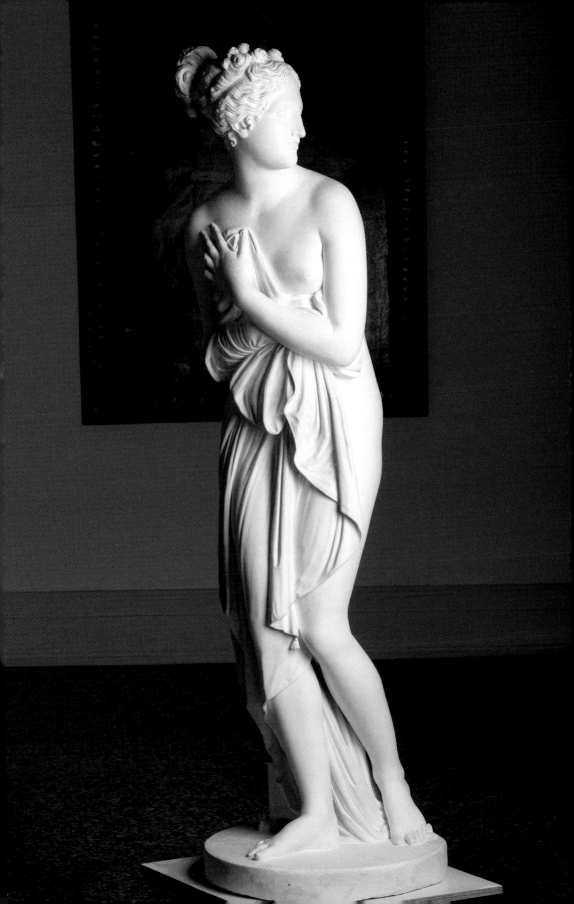

• The Three Graces

1812, terracotta model

In addition to the sketch model for the *Penitent Magdalene,* the Museo Civico of Bassano del Grappa (VI) contains the precious terracotta model of *The Three Graces.* The work, with its eventful collecting history, still has its original case in poplar wood and padded green silk fabric.

In Antonio Canova's repertoire, the three figures of Aglaia, Euphrosyne and Thalia, the patronesses of artists, are depicted as nude figures embracing and set in a circle. The harmonious interlacing of their arms serves here to give a soft abandonment to the figures who, in supporting each other, form almost a single group of requited affection and sensuousness.

The sketch model of the *Three Graces* was purchased by private treaty for €400,000 by an anonymous Italian private buyer in Florence in 2003. It was subsequently acquired by right of pre-emption by the municipality of Bassano del Grappa. It came from the collection of the important antiquarian Giancarlo Gallino in Turin and belonged to a Florentine family of sculptors called Fantacchiotti. Its first owner was Abbot Melchiorre Missirini, a friend of Canova's. The sketch model was personally made by Canova for Joséphine de Beauharnais, Napoleon's first wife, who died in May 1814. Her son Eugène would commission the final marble work now exhibited at the Hermitage in Saint Petersburg (a second version commissioned by the Duke of Bedford is in London at the Victoria and Albert Museum). At Possagno (TV) there is the plaster model of the work today in Russia. VP

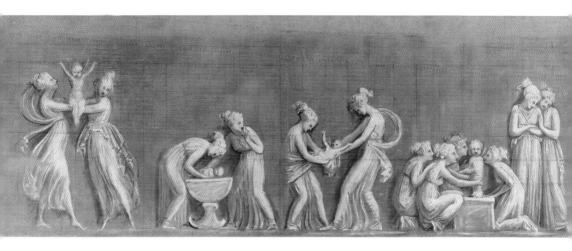

• *The Market for Cupids*

c. 1806, tempera, oil, white lead and charcoal on canvas prepared with squared grey stucco

The canvas is part of the series of 15 monochromes in Bassano, many of which are painted, as in this case, on both the recto and verso. The series, to which are added the three in the Museo Correr in Venice, one in Possagno (TV) and one in a private collection, can be divided into two thematic groups. The first is attributable to the theme of "gracefulness" and the second is elegiac in character. This painting belongs to the first group, depicting dancers, playful female figures, nymphs and cupids. As conjectured by scholars, the painting was made as preparation for two series of decorative bas-reliefs, never made, depicting dancers and the Pompeian theme of the market of Cupids. The squaring shows that they were painted with a view to being transferred to a sculptural bas-relief. The monochromes with a graceful character were translated almost complete into the tempera on a black field currently preserved in Casa Canova at Possagno. The one related to our canvas is the largest in the whole series, being almost three metres long. The theme of the market for Cupids was brought to the fore by a painting discovered in Herculaneum (Naples) in 1759. Spread throughout Europe by being reproduced in prints, and later the subject of a famous painting by Joseph-Marie Vien, it became an iconographic *topos* of the neoclassical visual universe that appealed to Canova with a certain insistence. The three compositions of the two great monochrome works were ideally imagined by Canova as decorations for the "small temple" shown in the frontispiece of the ten engravings reproducing the analogous tempera on a black ground (Possagno, Museo Gypsotheca Antonio Canova), made between 1811 and 1813 by various engravers and entitled *Mercato di Amore ideato da Antonio Canova per fregio di un piccolo tempio.* VP

• *Hercules Slaying his Children*

1799, oil on paper glued to canvas

The painting, initially placed in the sculptor's birthplace at Possagno (TV), became part of the core group of works selected by his brother Giovanni Battista and donated to the Museo Civico of Bassano.
The subject, drawn from Euripides and an ode by Pindar, shows Hercules in his madness slaying his own children, mistaking them for the children of Eurystheus.
Painted in 1799 at Possagno, during one of his stays in his native village, it was left partly unfinished on the artist's return to Rome in November of that year.
Its purpose, like almost all his paintings, was not the creation of a painting in itself, but the study of poses and compositions that, if considered valid, would be used in sculptures. In this case, with the same theme, Canova created a wax model now in the Museo Correr in Venice, several studies on canvas and a plaster bas-relief preserved at Possagno. VP

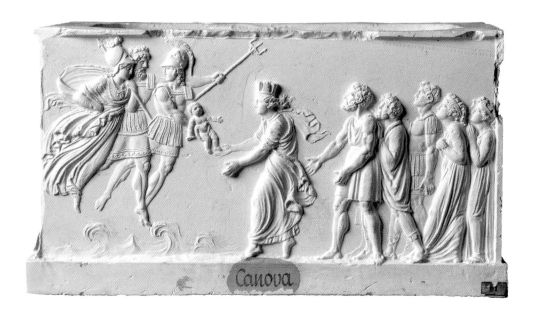

• *Model for the Funerary Monument to Horatio Nelson*

1806–1807, plaster

The circumstances that led to the conception of a funerary monument to Admiral Horatio Nelson, never completed, are unclear. The hero died on 21 October 1805 at the Battle of Trafalgar, during which the French fleet suffered a humiliating defeat. In 1806, despite not having received a precise commission, Canova produced several sketches for the monument: the wax panels in Casa Canova in Possagno (TV); the model of the whole work made in wax, plaster and terracotta in the Gypsotheca at Possagno; four models (today three) in terracotta and wax of the allegorical figures of the continents, and the plaster model of the central rectangular sarcophagus, both in the Museo Civico in Bassano. This last work much simpler than the more complex multimedia one at Possagno, might be an earlier version.

The news of Canova's project arrived in England in 1807, eliciting many protests, since the artistic community in London would have preferred to entrust the monument to a British artist. In fact, it was John Flaxman who received the commission and erected the monument in St Paul's cathedral in London.

The plaster model in the Museo Civico of Bassano depicts the *Allegory of the Birth of Horatio Nelson with Minerva, Neptune and Mars Consigning the Infant Hero to England* (an episode also present in one of the monochromes in the museum). The other two reliefs on the monument were intended to represent *The Arrival of the Body of Horatio Nelson Welcomed by the Personifications of England, Scotland and Ireland* and the *Glorification of Horatio Nelson.* VP

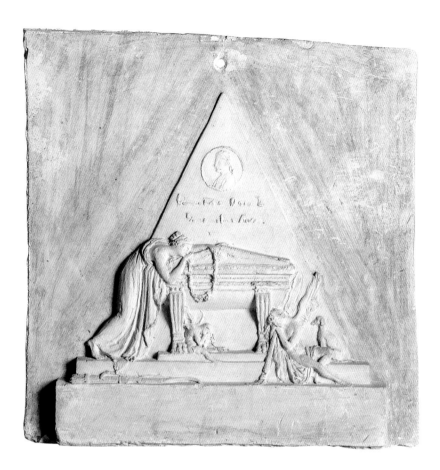

• *Funerary Monument to John Frank Newton's Friend*

1794, plaster

On 31 May 1794 Canova signed a contract with the American John Frank Newton, resident in Florence and not otherwise known, for a funerary monument, never completed, which was to commemorate a "loving friend" of Newton who had died young.

The sketch model (the only surviving record of this monument), conceived as a bas-relief to be set against a wall, consists of a pyramid that forms the background, including in the upper part the image of the deceased set in a clipeus framed by the symbol of the uroboros (a snake biting its tail) and the inscription. Set against the pyramid is a sarcophagus, on which, to the left, rests a weeping female figure with a garland of flowers in her hand. To the right of the steps of the base is seated a funerary genius in a sorrowful attitude. Beside the genius is a dog and a winged cupid, weeping and with his hands over his eyes, is set beneath the urn. The genius was intended to express an

allegory of friendship, with the dog symbolizing fidelity and alluding to the friendship between the deceased and the client.

Particularly significant, the Newton model should be added to the models and preliminary ideas that Canova was creating in the same years for the *Monument to Titian*, to be placed in the Basilica of Santa Maria Gloriosa dei Frari. They bear witness to the sculptor's fundamental reflections on the sepulchral theme, and also mark the transition between his youthful papal sepulchral monuments and those in his subsequent work. VP

LUIGI ZANDOMENEGHI
(Colognola ai Colli, Verona 1778–Venice 1850)

Homage to Canova

1827–1828, marble and gilded wood

Luigi Zandomeneghi, a sculptor from Verona, trained as an artist in the workshop of Giovanni Ferrari and at the Accademia in Venice. After a period spent in Rome, where he saw much of his friend Antonio Canova, Zandomeneghi returned to Venice. When the chair of sculpture of the reformed Accademia di Belle Arti fell vacant, he was appointed professor and held the post till his death in 1850.

The work in the Museo Civico of Bassano del Grappa (VI) comes from Villa Comello in Mottinello Nuovo (in the municipality of Rossano Veneto (VI), a small town between Bassano del Grappa (VI) and Cittadella (PD)). The client was Giuseppe Comello, a Venetian nobleman, who had contacted Antonio Canova shortly before his death to commission one of his dancers in marble, never completed. To commemorate the sculptor's death, Comello purchased some bas-reliefs by the artist: *Socrates Taking Leave of His Family*, *The Death of Socrates* and the *Return of Telemachus*, and commissioned Luigi Zandomeneghi to produce a commemorative sculpture to be placed in the small temple of his villa. *Homage to Canova* is a marble sculptural group consisting of a nude youth (*Genius*) embraced by a naked female figure (personifying *Sculpture*), while behind him a child (*Mercury*) carves the names of Antonio Canova and Giuseppe Comello in stone. An interesting detail is that *Sculpture* holds in her right hand a pair of sculptor's dividers, an invention of Professor Zandomeneghi's for which he received awards. On the front of the cube-shaped pedestal, depicted in bas-relief, is the portrait of Canova in profile. On the other sides there appear three of Canova's sculptures: *Religion*, the *Graces* and the group of *Beneficence*. From the raised left hand of *Genius* appears, like a flame, a small *Hebe*, a reproduction in gilt wood of Canova's famous model of the cup-bearer of the gods in the act of pouring out the nectar of immortality.

The first plaster version of the sculpture was exhibited at the annual exhibition of the Accademia di Venezia in 1823, when it was titled *Homage Rendered to Creative Genius, Sculpture and the Prerogatives of Canova.* The finished marble, however, was only shown in 1827. The following year it was moved to the villa at Mottinello Nuovo, and perhaps on this occasion the sculptor added his signature and date, as appears in the inscription on the marble block. *Homage to Canova* remained at Villa Comello for a hundred years, until 1928, when it was bought by the industrialist Ernesto Moizzi for his villa (Ca' Cornaro) at Romano d'Ezzelino (VI). In late 1955, Commendatore Moizzi donated the work to the Museo Civico of Bassano del Grappa. It was inventoried in February 1956 with the title *Genius and Sculpture, Homage to Canova.* In December 1955 the sculptural group was already in Bassano del Grappa (VI) and the museum's director, Gino Barioli, wrote to the superintendent of the Galleria dell'Accademia of Venice, Vittorio Moschini, informing him of the placing of the work at the foot of the staircase in the hallway, adding that the "two windows" in the back wall, still visible today, would be closed to improve the lighting of the large sculpture. VP

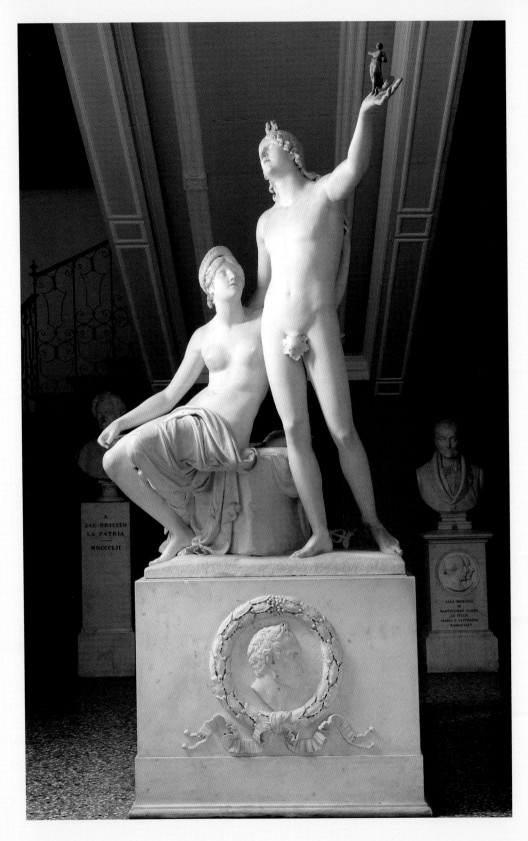

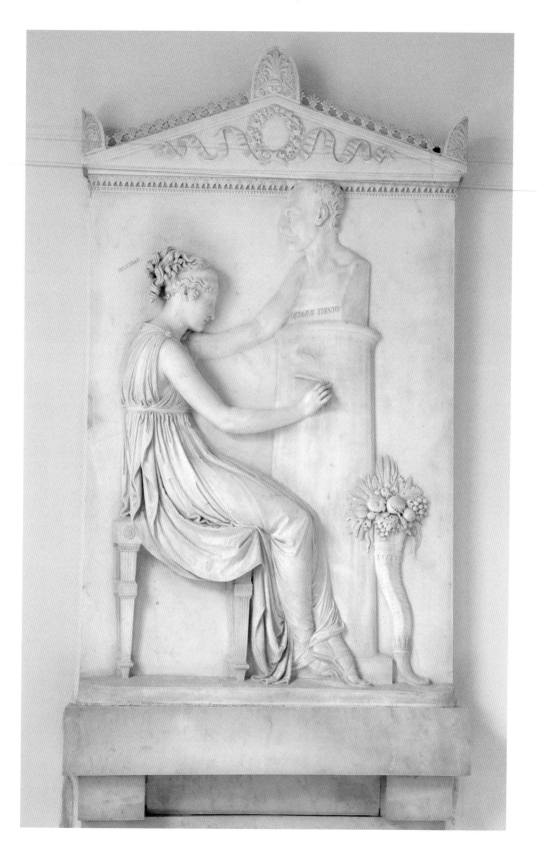

Vicenza

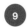 **Former monastery of San Pietro, now Residenza Ottavio Trento**

• *Funerary Stele of Ottavio Trento*

1813–1815, marble

Count Ottavio Trento died in Vicenza on 8 May 1812. The town council immediately contacted Antonio Canova to create a funerary monument in his honour, since he had been distinguished through the years by many acts of generosity towards the needy in his city. In 1810, his lavish funding enabled the construction of a "House of Shelter and Industry", the Residenza Trento, in the former Benedictine monastery of San Pietro. The antiquarian Francesco Testa of Vicenza was in contact with the sculptor then resident in Rome. On 20 June 1813, despite numerous commitments, he accepted the commission. The negotiations led to an agreement for a fee of 12,000 francs in exchange for a funerary stele in marble. It was to be similar in shape and size to that made for Canova's friend Giovanni Volpato of Bassano placed in the Basilica of the Santi XII Apostoli in Rome. Instead of the allegorical figure of *Friendship* seated weeping before the bust of the deceased, it represented, as Leopoldo Cicognara recalled, "*Felicity* gratefully carving on the supporting column of the bust the name of the liberal benefactor who generously assisted the needy". At the bottom right, resting against the column, a long cornucopia filled with fruits and crowned with herbs and flowers is a symbol of prosperity and abundance. In the summer of 1814 Canova requested a portrait of the count in profile, as a model for the one to be set in the now completed relief. The *Funerary Stele of Ottavio Trento* was delivered only at the end of 1815 because of delays in the payments. The Museo Civico in Vicenza contains a plaster plaque bearing the portrait of Ottavio Trento, dated 1814. This may be the portrait requested by Canova for the creation of the final marble. VP

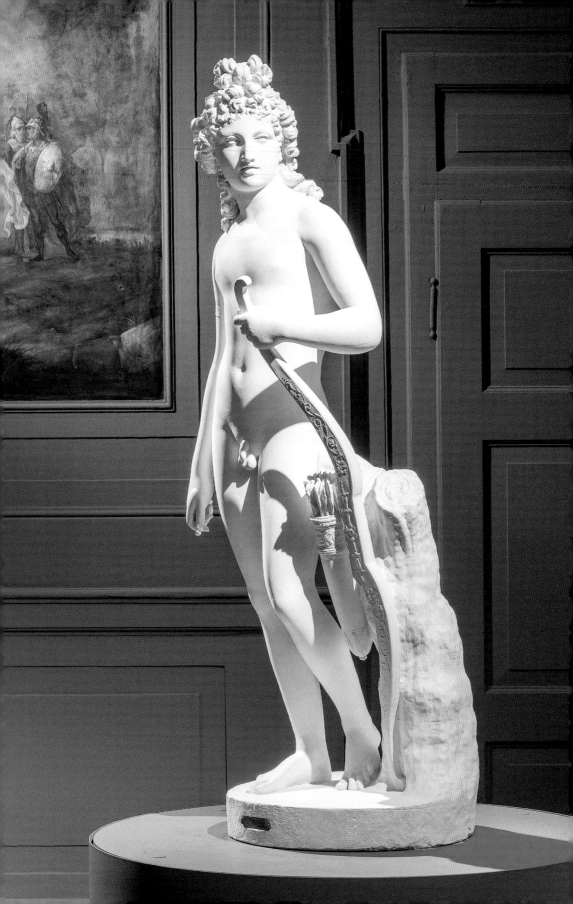

Verona

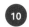 **Casa Museo Palazzo Maffei**

• *Amorino*

1789–1790, plaster cast

The *Amorino* is one of Canova's most successful works, so much so that it was replicated five times with variations, the last of which was titled the *Young Apollo*. The work on display here is the second replica of the *Amorino* (Anglesey Abbey, Cambridgeshire, property of the National Trust), sculpted between 1787 and 1789 for John Campbell (from 1796 Baron Cawdor). The cast has been identified as the one that belonged to Senator Giovanni Falier of Venice. The original mould was used to make casts of two other *Amorini* sent to the procurator Antonio Cappello in Venice and Girolamo Zulian in Padua. The gift of the casts was a token of gratitude that Canova presented to those who had supported him at the outset of his career (Girolamo Zulian, Giovanni Falier, Antonio Cappello and Abbondio Rezzonico). The first version of the *Amorino* had the features of the young Polish Prince Henryk Lubomirski. In 1787 Canova made a new version of the *Amorino*, commissioned by Campbell, giving it ideal features and sweet, smooth limbs. The client was so enthusiastic that he added another one hundred sequins to the sum agreed on with the sculptor.

The Campbell *Amorino* is portrayed naked and turning his head slightly to the left, framed by thick, curly tresses. Resting against a tree trunk, from which hangs his quiver, he holds in one hand the bow with a floral ornament and in the other an arrow (lost both in the marble and the cast).

The plaster was recently added to the Luigi Carlon collection and found a home in Palazzo Maffei, which curiously also has a portrait of Canova on the entrance staircase, accompanying the *Allegory of Art*. EC

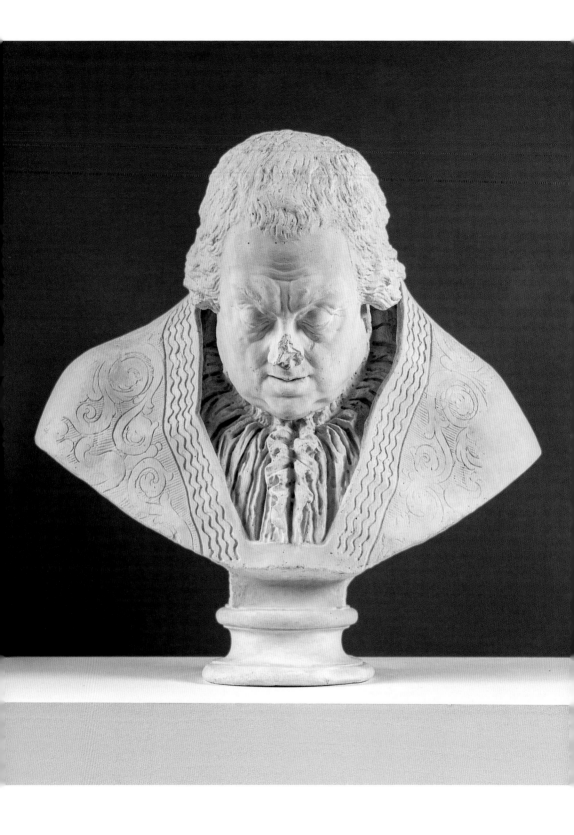

• *Bust of Pope Clement XIII* and *A Funerary Genius* for the *Funerary Monument to Pope Clement XIII Rezzonico*

plaster cast

In 1858 the Marquis Giovanni Pindemonte, grandnephew of Ippolito Pindemonte and a descendant of Senator Abbondio Rezzonico, gave the city of Verona a series of works in plaster by Canova. They include a *Bust of Canova*, a *Psyche*, an *Amorino*, three *Busts of Pope Clement XIII*, two half-length figures of a *Funerary Genius* for the *Funerary Monument to Pope Clement XIII*, together with the *Bust of Religion* and two *Lions*. As the sources of the time report, the works originally belonged to the collection of Abbondio Rezzonico, a friend of Canova's who had commissioned them. He had the imposing *Funerary Monument to Pope Clement XIII* erected in St Peter's in Rome. Of this large collection, exhibited to the public ever since its donation, only two *Colossal Busts of the Pope* and a half-length figure of the *Funerary Genius* have survived. The collection caused a stir in the city, with the result that in 1882 Salesio Pegrassi made two copies in tuff of the *Lions*, to be placed at the entrance to the Monumental Cemetery of Verona.
With the *Funerary Monument to Pope Clement XIII*, Canova's other funerary masterpiece for Clement XIV in the Basilica of the Santi XII Apostoli in Rome, Canova confirmed his mastery of a theme that the great sculptors of the past had also explored. The *Funerary Monument to Pope Clement XIII* is a composition of superimposed volumes. At the top is the pontiff, seen kneeling in prayer, having removed the triregnum or papal crown, a sign of temporal power. This pose brings out the pastoral aspect of the pope and exalts his moral qualities and physical presence, portly and weary under the burden of his magnificently sculpted garments. Beneath the figure of the pope there is the striking personification of *Religion*, wearing the robes of the high priests of Israel, her head surrounded by a radiant light and her hand supporting a great cross. On the opposite side is the *Funerary Genius*, expressing sorrow but also hope in the life to come. The *Funerary Genius* was greatly appreciated for the grace of its ideal forms, in striking contrast

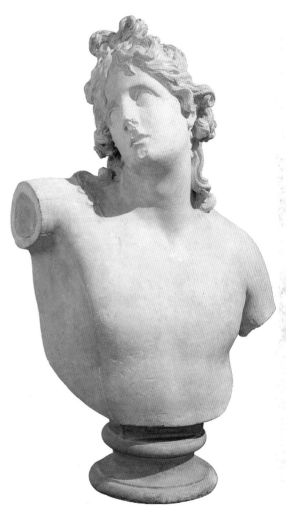

to the two powerful lions guarding the tomb, emblems of the pope's moral strength and his homeland Venice.
Other plaster casts of the same monument can be seen in the Museo Gypsotheca at Possagno (TV), the Museo Correr in Venice, and the Gallerie dell'Accademia in Venice. EC

Padua

Canova's relationship with Padua began when he was a young man. At the time, the city was enriched with important works by Canova, preserved in numerous private collections, some of which can be admired today in the Musei Civici agli Eremitani.

Ambassador Girolamo Zulian had an important collection, having managed to install "two Canova rooms" in his palazzo, containing numerous works in plaster, including the bas-reliefs of the *Stories of Socrates*, pieces of the *Monument to Pope Clement XIII*, the rare cast of *Cupid and Psyche Embracing*, and *Psyche* and *Amorino*. Except for the bas-reliefs, the other works in plaster passed to the collection of Daniele degli Oddi and later, in the first half of the twentieth century, they ended up far from Padua.

Another collector of his works in the city was Daniele Francesconi, who owned the cast of *Napoleon Bonaparte as Mars the Peacemaker,* later sold to Eugène de Beauharnais (now in the Pinacoteca di Brera in Milan).

Finally, another collection still present in Padua is that of the Papafava family. In addition to these works Padua has lost an important work in marble: the *Funerary Monument to Prince William of Orange Nassau*, which was transferred from Padua at the request of the House of Orange in 1896 and taken to the Nieuwe Kerk in Delft in the Netherlands, leaving a bronze copy in the sacristy of the church of the Eremitani.

A unique work by Canova, *Countess Lodovica von Callemberg's Cinerary Vase*, placed outside the church of the Eremitani, was damaged during air raids in 1944. It could possibly be recovered and exhibited to the public. EC, VP

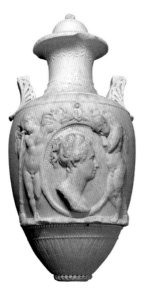

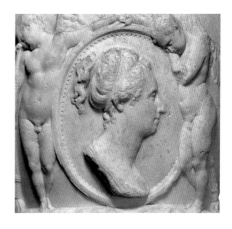

Antonio Canova, Cinerary vase of Countess Lodovica von Callemberg, Padua, Museo Diocesano, on deposit from the parish church of the Eremitani, Padua.

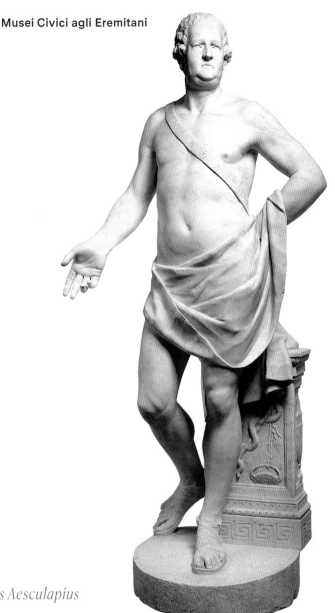

• *Alvise Valaresso as Aesculapius*

1778, marble

The work was commissioned from the young Antonio Canova by Ernestina Stahrenberg, the wife of Carlo Spinola of Genoa, resident in Venice. It was to be a full-length portrait of Senator Alvise Valaresso, the public health officer in Padua (in 1630 and 1631), whose energetic measures put an end to the scourge of plague in the city. The statue was intended to be included among the series of "illustrious men" in the Isola Memmia of Prato della Valle, but never reached its destination due to the failure to pay for it. In 1794 the work was purchased by the lawyer Giambattista Cromer and placed in his villa at Monselice (PD). In 1887 Cromer's great-grandson Angelo Saggini donated it to the Musei Civici in Padua. For this work Antonio Canova diverged from the custom at Prato della Valle of representing the personages in modern costume, choosing to portray Alvise Valaresso as Aesculapius, the god of medicine in Greek and Roman mythology. The idealization of Valaresso is only partly successful. While the naked body recalls Roman Greek statuary, the face is characterized in markedly realistic terms. VP

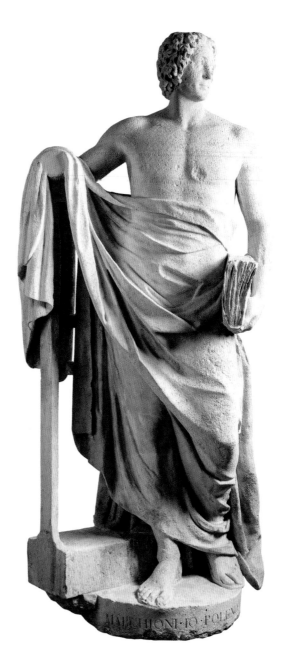

• *Giovanni Poleni*

1779–1780, stone

The work was commissioned by Leonardo Venier to honour his master at the University of Padua, the distinguished Venetian mathematician, physicist and engineer Giovanni Poleni (1683–1761), as recorded by the inscription carved on the pedestal: "MATHEMATICO PRECLARISSIMO / LEONARDVS VENERIVS P.V. / PRAECEPTORI SVO / GRATO ANIMI MONUMENTVM / P."
The statue is inserted among the "illustrious men" on the Isola Memmia of Prato della Valle. It represents the intellectual wearing a toga in the guise of a classical sage, holding in one hand a book he wrote, *De motu aquae mixto*, and in the other an invention of his. Canova began working on the stone block in 1779 but stopped for his forthcoming trip to Rome. On his return the work was significantly modified, especially in the drapery, influenced by some famous ancient marbles. In the figure of Poleni as in Valaresso, the idealization of the likeness is not wholly successful, since the face still has a very eighteenth-century character.
In 1963 the work was placed in the Museo Civico and replaced by a copy made by Luigi Strazzabosco. VP

• *Penitent Magdalene*

1795, plaster model

The *Magdalene* in Padua is the plaster model of the work preserved in the Musei di Strada Nuova at Palazzo Bianco in Genoa.
The marble was initially intended for Monsignor Giuseppe Priuli, but was ceded to the commissioner of the Cisalpine Republic Jean-Francois Julliot and finally purchased by Giovanni Battista Sommariva, an important Lombard collector. In 1808 he sent it to the Paris Salon and then gave it a magnificent setting in his Parisian palace, thus ensuring its extraordinary popularity.
The work's development can be followed from the initial idea visible in the sketch in the Museo Correr in Venice, where the Magdalene is shown praying with hands clasped, then in the terracotta in the Museo Civico of Bassano del Grappa (VI), where Canova introduced an iconographic variant, making the figure

more melancholy and expressive, where the arms are open and stretched forward along the body in the gesture of supporting the cross and the head is tilted to one side. In this second drawing, the setting on a cliff is also sketched in, serving as the basis of the composition, and the iconographic attribute of the skull. Both elements are again found in the plaster model from Padua and in the final versions in marble (Genoa, Palazzo Bianco; Saint Petersburg, Hermitage).
The plaster in the Museo agli Eremitani comes from the collection of the Paduan notary Antonio Piazza (1772–1844), who kept it in the dining room of his residence in the gardens of Villa Giustiniani at Vanzo in the municipality of San Pietro Viminario (PD). It was purchased by the municipality of Padua from the notary's heirs in 1856. vp

• *Stele Giustiniani*

1796–1797, marble

In 1795 the Paduan authorities commissioned Antonio Canova to sculpt a monument to celebrate the captain and deputy mayor Girolamo Giustiniani, who was coming to the end of his term of office. Canova designed a stele depicting a seated woman, the personification of the city of Padua, in the act of writing his name beneath his portrait in profile. Her left arm bears the seal of the city and on her lap is placed the caduceus, a symbol of prosperity and peace; above flies an owl that represents the protection of Minerva. Below this elegant allegory is a stone block with reliefs narrating the city's mythical founding by Antenor. In 1797 the marble was completed but the fall of the Republic of Venice and the French occupation changed the priorities. The Paduans asked for the portrait of Girolamo Giustiniani to be replaced

by that of Napoleon Bonaparte. Canova refused and changed only the inscription to "NAPOLEON ME AUSPICAT". The stele did not leave the artist's studio until French rule was replaced by Austrian. It was then decided to efface the bust and replace it with a large plaque on which to carve a new dedication, this time to the uncle of Girolamo Giustiniani, Nicolò Antonio Giustiniani, who was bishop of Padua from 1772 to 1796 and founder of the Ospedale Civile. The work arrived in Padua in 1802 but was placed in the premises of the Congregazione di Carità only in 1806 and then moved again in 1821, in the presence of Antonio Canova, to a small church attached to the city hospital. In 1896 it was added to the museum collections. VP

Palazzo Zuckermann is an imposing early twentieth-century building in Padua located in Corso Garibaldi, the thoroughfare built in the nineteenth century to connect the train station to the city centre. Located not far from the Museo agli Eremitani, it houses the Museo delle Arti Applicate on the ground and first floors and the Museo Bottacin on the second. There are many associations with Canova here. In the hallway there are four nineteenth-century plaster casts made from Canova's models of *Psyche with a Butterfly* (two versions), the *Bust of Helena* and the *Terpsichore*. On the first floor, in the section devoted to works in ivory, there are plaquettes by Giuseppe Rizzoli (1785–1868), clearly exemplifying his love of Canovian classicism; they replicate in miniature different works by the Venetian sculptor: the *Stele Giustiniani*, the *Stele of Prince William of Orange*, the urn of Countess Lodovica von Callenberg, the relief of *Feed the Hungry*, the statue of *Napoleon Bonaparte as Mars the Peacemaker*, the sculptural group of *Theseus and the Centaur* and the *Tomb of Antonio Canova* in the Frari. On the second floor are the collections that Nicola Bottacin (born in Vicenza and a wealthy entrepreneur in Trieste), bequeathed to the city of Padua. It includes a rare terracotta bust by Antonio Canova: the *Portrait of Doge Paolo Renier*. VP

• *Portrait of Doge Paolo Renier*

1776–1779, terracotta

This is a youthful work by Antonio Canova; its autograph has often been questioned because of discrepancies between the documentary sources.

The bust was commissioned in 1776 by the Venetian senator Angelo Querini, a political ally of the noble Paolo Renier, elected doge in 1779. Hence it is logical to assume that the modification of the portrait by the sculptor with the addition of the ducal *corno* dates from this time. It is also said that after a disagreement between the doge and Querini, the latter struck the sculpture, which he kept at Villa Querini at Altichiero, a district north of Padua, and shattered it.

In 1861 Constantine Querini, Angelo's nephew, sold the fragments of the bust to the antiquarian Angelo Rizzoli of Trieste. He had the work restored and, after two years of negotiations, in early 1864, he sold it to Nicola Bottacin, a wealthy textile merchant, for 500 francs. Bottacin placed the torso in his villa in the hills of Trieste, where he kept a remarkable numismatic and artistic collection. He donated it to the city of Padua between 1865 and 1871.

After recent restoration, the *Portrait of Doge Paolo Renier* by the young Antonio Canova has recovered the freshness typical of his early works. The doge's face above all is very successful, being modelled with great delicacy and naturalness. VP

Palazzo Papafava dei Carraresi

In 1806 the Papafava family bought Palazzo Trento in Padua as a new family home. Its renovation was overseen by the brothers Francesco (1782–1848) and Alessandro (1784–1862). At the time Alessandro Papafava was completing his studies in Rome under the tutelage of Antonio Canova, and there, in spring 1806, he bought and sent to Padua three of his works in plaster: the *Perseus Triumphant*, the boxer *Kreugas* and *Ebe*. In Rome in 1817 Francesco Papafava purchased two works in plaster, the *Borghese Gladiator* and the *Apollo Belvedere*, to accompany the *Kreugas* and *Perseus*, the plaster works by Canova that his brother Alessandro had purchased eleven years earlier.

The statues were grouped in the old ballroom of the Papafava residence to create a clear comparison between the classical and neoclassical style, or between ancient and modern. Alessandro had four corner niches made in the ballroom, where he placed each work by Canova opposite its ancient counterpart. They are still in their original location today. EC

• *Perseus Triumphant*

1797–1801, plaster cast

Canova depicted *Perseus* with the head of the Medusa in his left hand and the harpe sword in his right. His expression of strength and proud nobility is a reinterpretation of the famous ancient statue of the *Apollo Belvedere* (Vatican, Vatican Museums). The sculptor carefully studied the classical prototype to reproduce the pose faithfully. Canova managed to recreate a timeless beauty based on harmony and a perfect balance between the representation of nature and its idealization. The work was initially intended to be placed in Foro Bonaparte in Milan, in homage to the victorious French army. Finished and held to be the equal of its illustrious ancient model, it was purchased by Pope Pius VII to be set on the pedestal in the Belvedere courtyard in the Vatican, left empty after the *Apollo* was taken to the Louvre with other works requisitioned by the Napoleonic army following the Treaty of Tolentino in 1797. EC

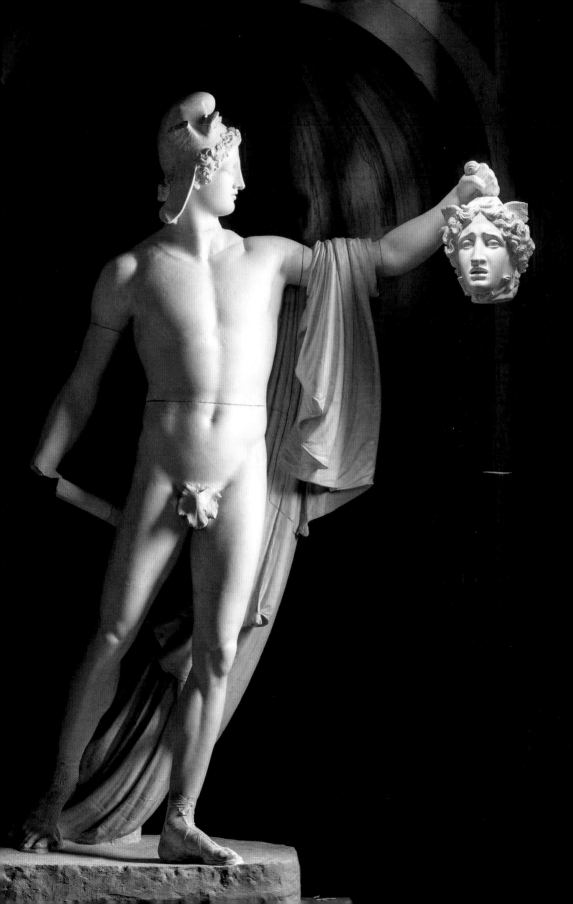

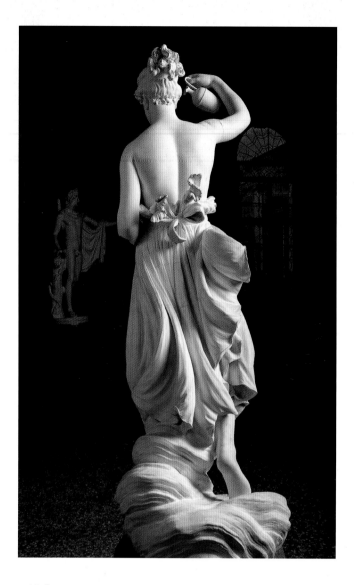

• *Hebe*

1806, plaster cast

On one of his visits to Canova's studio, Alessandro Papafava saw the second version of *Hebe* made for Empress Joséphine de Beauharnais, of which he noted: "Among the finished works is a copy of the Albrizzi Hebe, varied only in the way she holds the cup." Canova produced four versions of *Hebe* at different times, the first two with a cloud under the figure's feet (Berlin, Alte Nationalgalerie; Saint Petersburg, Hermitage) and the last two with a tree trunk at the base (Bakewell, Chatsworth, Devonshire Collections; Forlì, Museo San Domenico). The cloud was eliminated because it was considered a detail of Baroque origin. The success of the *Hebe*, confirmed by numerous copies, was due, in addition to the pleasantness of the subject and the dynamism of the figure in motion, to the small size of the statue, which made it suitable to decorate a dining room. Canova's mastery was evident in the dynamic pose of the figure in flight, a difficult form of sculptural virtuosity, expressed by the way her garments cling to her body, in the front view, and their movement behind, making Hebe appear about to fly into the wind to the gods. EC

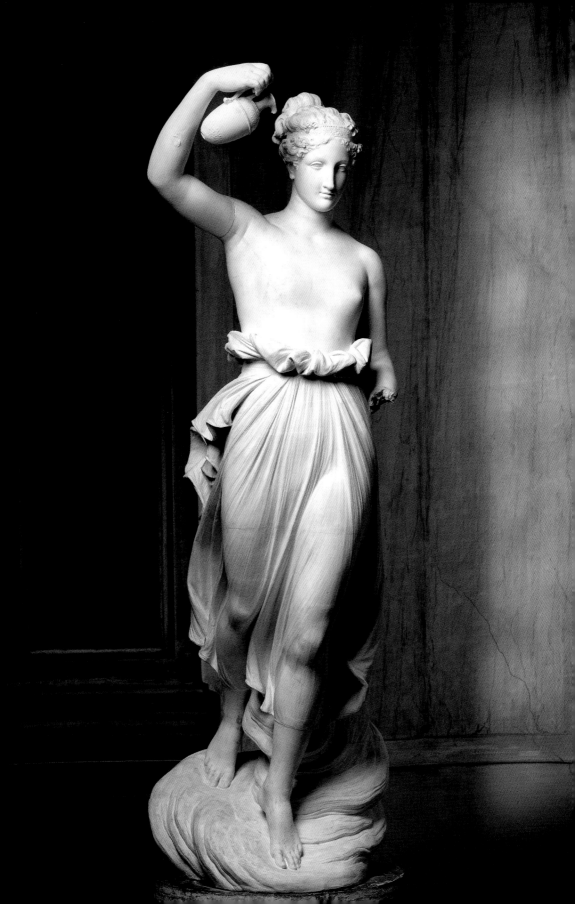

15 **Prato della Valle**

GIOVANNI FERRARI
(Crespano del Grappa, Treviso 1744–Venice 1826)

Antonio Canova Sculpting the Bust of Antonio Cappello

1796, Custoza stone (pedestal no. 68)

From 1775, the new governor of Padua, the Venetian patrician Andrea Memmo, decided to redevelop the land in front of the church of Santa Giustina in Padua by laying out as a piazza, today called the Prato della Valle. At its centre was placed an elliptical islet crossed by two avenues on the longitudinal and transverse axes and surrounded by a canal. Along the banks of the canal run stone balustrades decorated with statues commemorating illustrious figures associated with the city and its university. The 78 statues, by different artists, are set on high pedestals and all of the same height.

In this Paduan Olympus, an exception was made in 1796 and the statue of Antonio Canova was added to the 78 sculptures during his lifetime, in the act of sculpting the bust of Antonio Cappello. The work was commissioned by the procurator Antonio Cappello to honour his grandfather, his namesake, who had been podestà of Padua in 1706–1707. In reality, the work is a celebration of Canova engaged in sculpting a bust of the patrician. The procurator Cappello had Canova portrayed in return for the gifts received

from him of bas-reliefs based on the Homeric poems: a cast of the *Cupid* and one of *Venus and Adonis*.

Canova's gifts enriched Antonio Cappello's private collection, which was opened to the public in his apartment at the Procuratie Nuove in Venice on 5 September 1796, the day he became procurator of San Marco. The event was a triumph. The consecration of the young Venetian sculptor continued in 1796 with the publication in Venice of the first monograph on the artist. We can consider 1796 a true year of Canovian celebrations in the Veneto.

With *Antonio Canova Sculpting the Bust of Antonio Cappello* we perhaps have the only instance in which the master made a student of his immortal. It was the work of Giovanni Ferrari, the nephew of Giuseppe Bernardi known as Torretto, who had been Canova's first teacher. On Torretto's death Canova studied for three years under Ferrari and then set up on his own. Ferrari was a little older than Canova and lived longer, enabling him to follow his whole career and be present at his funeral in St Mark's Basilica in Venice on 16 October 1822. EC

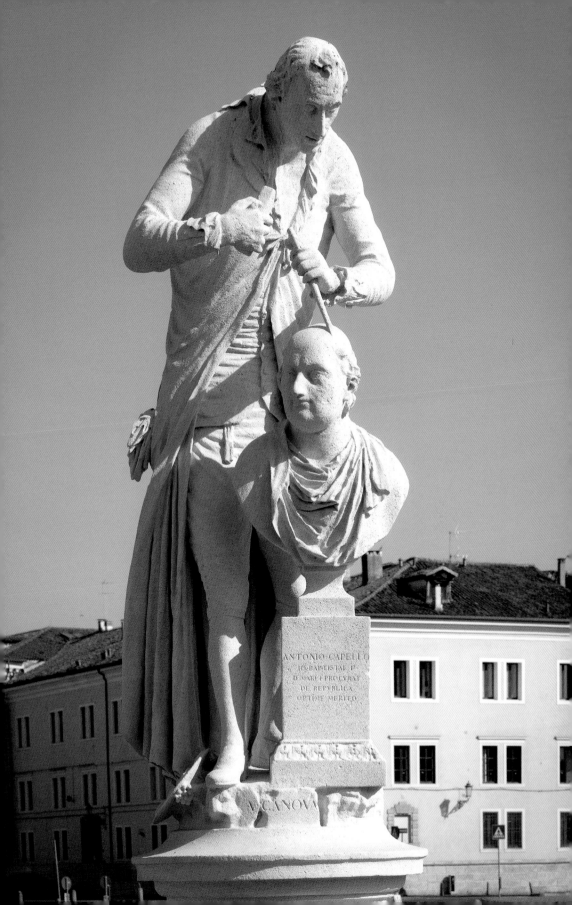

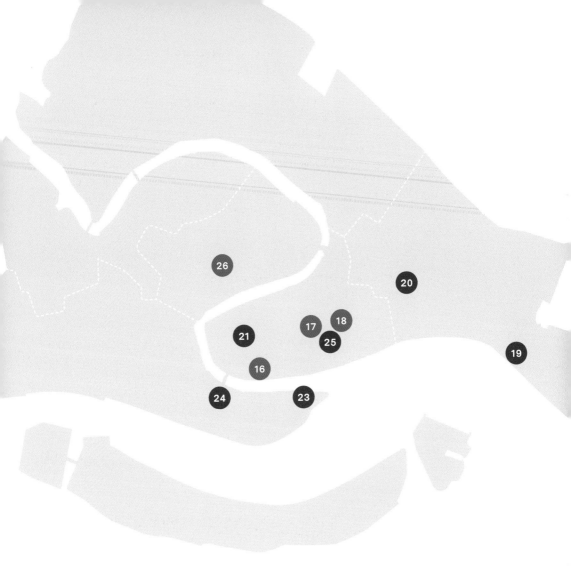

Venice

 works ⬤ places

16 Studio of Antonio Canova at San Maurizio
Ca' Granda – Palazzo della Prefettura

After his apprenticeship in Torretto's studio at Santa Marina, Canova began to work independently in a studio in the cloister of the church of Santo Stefano, where he produced the *Orpheus and Eurydice*. Later, he moved his studio to campo San Maurizio on the Grand Canal, where he worked on the the *Daedalus and Icarus*. In this studio (in 1862 it became a small garden annexed to the Lieutenancy, now the Prefettura) a plaque was placed commemorating Canova: "ANTONIO CANOVA / IN THIS PLACE / FORMERLY HIS WORKSHOP / SCULPTED IN MDCCLXXIX / HIS FIRST GROUP / DAEDALUS AND ICARUS." EC

17 The house where Antonio Canova died
Bacino Orseolo, Tron Bridge

Canova arrived in Venice from Possagno (TV) on 4 October 1822 as a guest of Antonio Francesconi, called Florian, the owner of the famous Caffè Florian in St Mark's Square. His health was already precarious and on 13 October, in the company of those dearest to him, his brother Giovanni Battista and Count Leopoldo Cicognara, he died in this house. In memory of the event, a plaque was placed on the facade of the building towards the canal: "HERE STOOD THE HOUSE OF THE FRANCESCONI FAMILY / WORTHY OF PERPETUAL REMEMBRANCE / FOR THE PRESENCE OF ANTONIO CANOVA / WHO DIED HERE/ ON 13 OCTOBER 1822." EC

18 The former premises of the Veneta Accademia di Pittura
Fonteghetto della Farina

From 1768 to 1776 Canova attended the Pubblica Accademia del Nudo, where in 1775, with the terracotta of *The Wrestlers* (now in the Gallerie dell'Accademia) he won second place in the competition for a copy after the antique. After the success of *Daedalus and Icarus* at the fair of Sensa in 1779, the sculptor was appointed "academician of merit" of the Institute, to which he donated, in accordance with the regulations, the terracotta sketch model of *Apollo* (now in the Gallerie dell'Accademia). In the hallway of the building there is still a plaque recording the foundation of the Academy. In 1807 the Academy was transferred to the complex of the Carità (the former church of Santa Maria della Carità), the present site of the Gallerie dell'Accademia, and in recent times it was located in the Ospedale degli Incurabili (now the premises of the Accademia di Belle Arti in Venice). The institute still preserves many memorials of Canova (letters, engravings, medals, etc.). EC

Venice

Antonio Canova is associated with Venice because it was here that he began his studies, produced his first works and died on 13 October 1822. Canova always had close ties to the city and some of its citizens who were his patrons, even after he moved to Rome. Many private Venetian collections have always possessed works by Canova in plaster and marble. Some have left Venice, such as the *Psyche*, which was taken to Bremen, or the *Bust of the Emperor Francis I*, which was transferred to Vienna, but a number of the city's cultural institutions still preserve numerous works and memorials of the artist. EC

 Museo Storico Navale della Marina Militare

• *Stele of Angelo Emo*

1792–1795, marble

In June 1792 Antonio Canova received a commission from the Venetian Senate for a funerary monument to Admiral Angelo Emo, the commander of the Venetian fleet, who had died unexpectedly a few months earlier in Malta. The sculptor delivered the finished marble some three years later, in 1795.

The last captain of the Serene Republic was an accomplished admiral, the inventor of an effective war machine: the floating battery. The strategist defeated the Barbary pirates based in Algiers and Tunis, whose incursions by sea had damaged Venice economically.

The monument takes the form of a classical stele. At the centre on a rostral column appears the bust of the commander crowned by a winged genius. At the bottom left, kneeling, is the allegory of *Fame* (or *History*) depicted in the act of writing the admiral's name followed by the appellative "IMMORTAL", still to be completed.

The work, intended for the Sala delle Quattro Porte in the Doge's Palace, was placed, to the sculptor's great disappointment, in the Armoury of the Arsenale. Today it is in the nearby Museo Storico Navale della Marina Militare. So great was the success of the work that the Senate gave Canova an annuity of one hundred ducats of silver a month and a gold medal was struck for the occasion, later donated by Giovanni Battista Sartori to the Museo Correr.

Close to the entrance to the museum is the church of San Biagio, where you can admire the principal part of Angelo Emo's sepulchral monument, an inspired work by Canova's teacher, Giuseppe Bernardi known as Torretto. Initially designed for the church of Santa Maria dei Servi and reconstructed in 1812 in the church of San Martino, since 1818 it has had its definitive location in the church by the Arsenale. The four bronze bas-reliefs displayed in the Museo Navale beside Canova's memorial were part of this tomb. VP

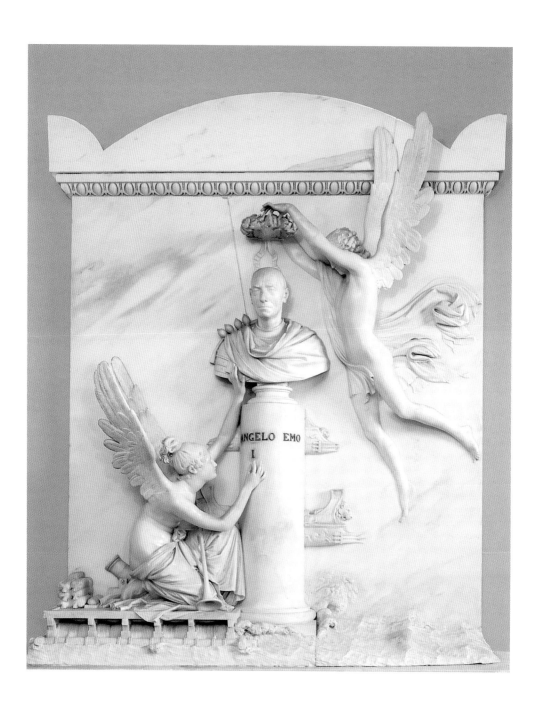

ANGELO EMO
I

• *Maria Letizia Ramolino Bonaparte (Madame Mère)*

1804, terracotta

Maria Letizia Ramolino Bonaparte, known as Madame Mère, was Napoleon's mother. A member of the wealthy Corsican bourgeoisie of Ajaccio, she led a long life, withdrawn and austere.

In 1804 Canova was contacted by Madame Mère to sculpt a full-length portrait of her. As he had already begun to do with the male figures of *Ferdinand of Bourbon as Minerva* (1800–1820, Naples, Museo Archeologico Nazionale di Napoli) and *Napoleon as Mars the Peacekeeper* (1803–1806, London, Apsley House), Canova decided to create a divinized portrait. Her actual appearance was therefore idealized and projected into a mythical and celebratory dimension through the explicit reference to a divinity or illustrious figure from the classical world. The artist drew inspiration from the statue of *Agrippina the Elder* in the Capitoline Museums in Rome. A celebrated ancient marble represents Nero's mother as seated at her ease in a chair. The solution of representing a female figure reclining on a chair would then be used in other portraits, such as *Princess Leopoldina Esterházy Liechtenstein* (1805–1818, Esterháyz, Privatstiftung, Eisenstadt, Schloss Esterházy), *Marie Louise of Habsburg as Concord* (1809–1814, Parma, Galleria Nazionale) and *The Muse Polyhymnia* (1812–1817, Vienna, Hofmobiliendepot Möbel Museum). Reference to the ancient model enabled the sculptor to avoid representing the figure in contemporary costume, out of keeping with the neoclassical vocabulary, but at the same time it helped enhance the distinctive character of the subject in the creation of the features. Letizia Ramolino Bonaparte is portrayed seated, with her body in profile and her face turned to the front. Her dress of ancient form consists of an extraordinary interplay of overlapping drapery. Madame Mère intended the work to be placed in the Tuileries before the throne of her son the emperor. Napoleon, however, refused the gift and decided to relegate the statue to a warehouse, from which it emerged only after the Congress of Vienna. It was later purchased by the very wealthy William Cavendish, sixth Duke of Devonshire and taken to England (Chatsworth House near Bakewell in Derbyshire).

The small clay sketch in the Fondazione Querini Stampalia was donated by Giovanni Battista Sartori to Giovanni Querini in 1857. The work is probably the second project presented by Canova to Maria Letizia Bonaparte before creating the final work in marble. In the Veneto, there is a miniature model of the Chatsworth House portrait at Possagno (TV), and a life-size cast of it in the Gallerie dell'Accademia in Venice. VP

• *Funerary Stele of Giovanni Falier*

1805–1808, marble

The sacristy of the church gives access to the small cloister with a museum containing sculptures, including the *Funerary Stele of Giovanni Falier*.

The stele is Antonio Canova's tribute to his first client the senator of the Serenissima Giovanni Falier. In 1773 the nobleman asked the young Antonio to make two life-size statues of *Orpheus and Eurydice* (Museo Correr) for his villa near Asolo (TV). In October of that same year at Possagno (TV) the sculptor began to rough out the two figures, which were finished in the following months in Venice in the cloister of the church of Santo Stefano. Several times during the years of his maturity in Rome, the artist declared that, before he died, he wished to make a statue to celebrate that "good old man" who had made him a sculptor. In 1808 the marble was finished but it remained in his studio in Rome, perhaps due to the death of the near-centenarian Giovanni Falier (1709–1808).

On the left, the bust of the deceased appears in profile on a pillar bearing an inscription, the dedication by Canova that identifies Falier as his friend and advisor. To the right, the figure of a woman, *Gratitude*, seated on a classical stool and swathed in soft classical drapery, weeps for the deceased, resting her head on her right hand placed on the base of the statue of the senator. The work arrived in Venice in 1823 and was sent to Villa Falier at Villa d'Asolo (formerly Pradazzi d'Asolo in the municipality of Asolo). Here it remained until after World War II when, in 1956, the Falier heirs decided to donate it to the church of Santo Stefano. VP

● HECTOR AND AJAX

The two colossal statues of *Hector* (1808–1816, marble) and *Ajax* (1811–1812, marble) remained in Canova's studio in Rome at his death. Leopoldo Cicognara, president of the Accademia di Belle Arti in Venice, wished to have them brought to Venice. In 1824 he sent a letter to the Austrian Emperor Franz Joseph I, urging him to buy them for the main hall of Palazzo Reale in Venice. The emperor declined the invitation, having already acquired works by Canova. Undaunted, Cicognara suggested to Baron Jacopo Treves De' Bonfili that he purchase the sculptures. He agreed because of his desire for social distinction. The works were sent to Venice in January 1827 and for the occasion Treves undertook to renovate the family's palazzo, in particular the great hall that was to contain the two works. The design of the room was entrusted to the eclectic Giuseppe Borsato, who was able to perform what Canova desired for the correct viewing of his statues: overhead lighting and a pedestal equipped with a pivot, so that the sculpture could be swivelled through 360 degrees. The prestige of Palazzo Treves De' Bonfili* was greatly increased by this unique feature of the great hall, making it one of the essential sights during visits by emperors or the great events organized in the city. Today, the two Homeric heroes in their original setting are still uniquely moving. The original models are in the Museo Gypsotheca at Possagno (TV). EC

* private residence, not open to visitors.

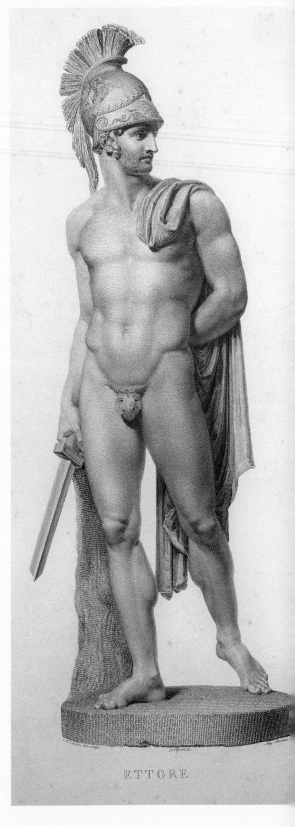

ETTORE

Giovanni Tognoli (draughtsman), Angelo Bertini, (engraver), *Ettore*, etching and burin, Possagno, Museo Gypsotheca Antonio Canova.

Giovanni Tognoli (draughtsman), Pietro Fontana (engraver), *Aiace*, etching and burin, Possagno, Museo Gypsotheca Antonio Canova.

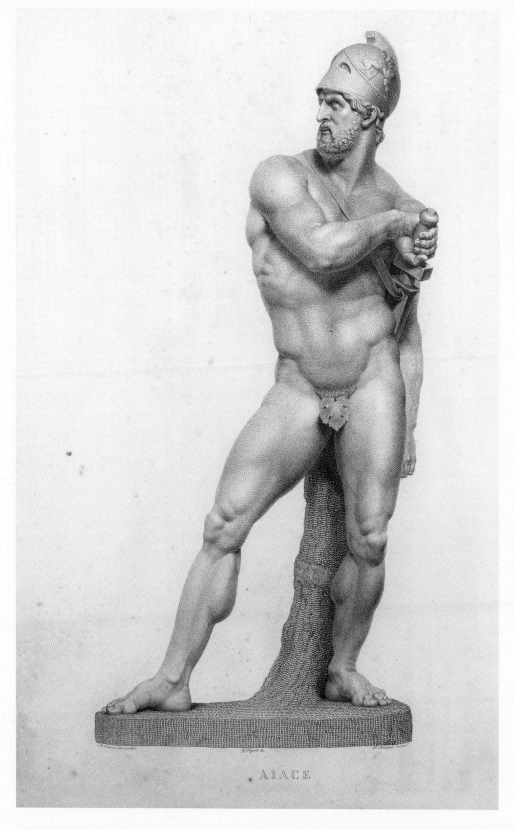

AIACE

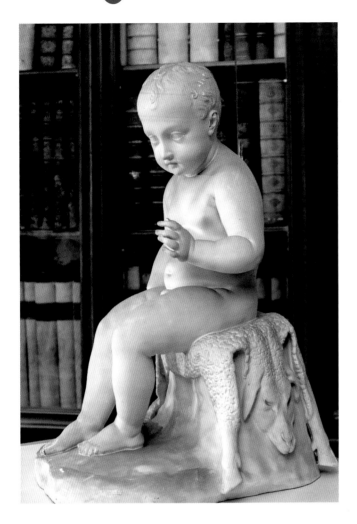

• *The Infant Saint John the Baptist*

1817, plaster cast

A chubby child – often interpreted as a portrait of the son of Napoleon and Marie Louise of Habsburg-Lorraine (Napoleon II of France, king of Rome) – seated on a sheepskin covering a tree stump, gazes devoutly at the cross (now lost) clasped gently in his hands.
Canova made two marbles of this religious subject. Formerly considered lost, both have recently re-emerged on the antiquarian market. The first, commissioned in 1817 by Alexander Douglas Hamilton, tenth Duke of Hamilton, passed into the hands of the French ambassador to Rome, Pierre Louis Jean Casimir, Count of Blacas d'Aulps, and was taken to Paris. On 22 June 1986 it was sold by Sotheby's

Monaco. The second was purchased directly from Canova's studio by Alexander Baring, Baron Ashburton, in 1822 and kept in his residence Bath House in Piccadilly. This version was put up for sale by Sotheby's London on 3 July 2019.
There are three plaster casts of *The Infant St John*, located in the Gypsotheca Canova at Possagno, the Museo Civico of Bassano del Grappa (VI) and the Library of the Congregazione Armena Mechitarista on the Island of San Lazzaro in Venice. The last of these was donated to the Armenian fathers by Antonio Canova's brother, Giovanni Battista Sartori. VP

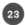
The house of the Somascan fathers in Venice was located (until the suppression of the order in 1810) in the large building designed by Baldassare Longhena next to the Basilica of Santa Maria della Salute. In 1817, in the second period of Austrian rule, the former Collegio Somasco was entrusted to the patriarch and transformed into a seminary. In those years, thanks to the scholar Giannantonio Moschini, who had also been a Somascan father, the seminary began to collect artworks from suppressed churches and monasteries in the region of the lagoon. Many works associated with Canova are kept here: a plaster medallion cast from the *Portrait of Antonio Canova* in the Frari monument by Antonio Bosa, a model of the *Genius of Italy Mourning the Death of Canova* by Giuseppe De Fabbris, engravings by Giovanni Volpato and a collection of plaster cameos made after the antique donated by Canova's brother, Giovanni Battista Sartori. Finally there is the *Portrait of Gianmatteo Amadei* now in the Pinacoteca Manfrediana, the diocesan museum of the patriarchate. VP

• *Portrait of Gianmatteo Amadei*

1776–1779, terracotta

On the wooden pedestal, the nineteenth-century inscription "AMADEI D. GIAMMATTEO C. R. S." records that the subject belonged to the regular clerics of Somasca in Vercurago (LC), commonly called the Somascan fathers. The work remained, presumably, in the Collegio Somasco after the death of Father Amedei (1730–1806) and so passed into the collections of the seminary. Here it was recorded in 1842 by the religious Giulio Cesare Parolari, editor of the posthumous volume by Giannantonio Moschini (1773–1840), *La Chiesa e il Seminario di Santa Maria della Salute in Venezia*. The bust is traditionally considered a youthful work by Antonio Canova. It is never mentioned in ancient sources on the artist and its status as an autograph work has often been questioned. Amadei's face is shaped in a very realistic and lively way. The religious man is given an affable expression, two piercing eyes, a spacious forehead covered by a skull cap, from which emerge strands of hair at the sides of his head. VP

The Canova collections in the Gallerie dell'Accademia are closely associated with the Accademia di Belle Arti, since the two institutions were one and the same until the end of the nineteenth century. In 1769, Canova enrolled in the Pubblica Accademia del Nudo at the Fonteghetto della Farina. The Academy's collection included some youthful terracotta sketch models (the *Wrestlers* of 1775 and the *Apollo* of 1779; two works made for the yearly student competitions); the first model for the *Theseus and the Minotaur* (today in the Museo Gypsotheca); a cast of the *Kreugas*; and a cast of the bust of *Napoleon*. When Napoleon re-founded the Academy in 1807, it moved to its present premises and Leopoldo Cicognara (a friend of Canova's with whom he discussed his ideas and an interpreter of his work) was appointed president. He felt that the collection of Canova's works was small and decided to increase it. *Mary Magdalene* (now in storage), *Paris, Madame Letizia* and the *Volpato*,

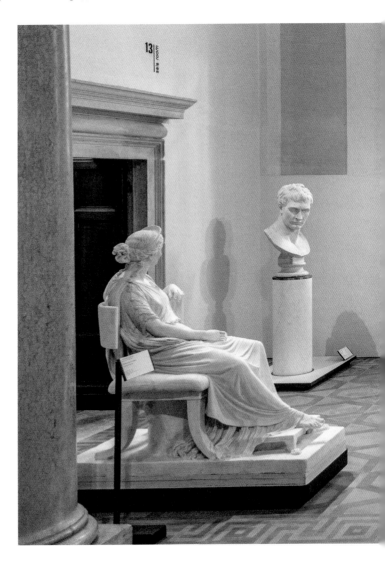

Falier, *Orange* and *Souza* steles were brought from Canova's studio in 1810. In 1817 the *Hebe* (now in the Museo Gypsotheca) and *Terpsichore* were added. In 1821 came the seven *Metopes* of the Tempio Canoviano to be rendered in stone, and after Canova's death, at the behest of his brother Giovanni Battista, came the colossal figures of *Hercules and Lichas*, *Theseus Slaying the Minotaur* and the *Horse* for the monument to Ferdinand I of the Two Sicilies. (The first two are now in the Museo Gypsotheca and the third is lost.) In the following years other works such as the models of the *Monument to Titian*, the cast of the *Pietà,* the *Bust of Leopoldo Cicognara* and the *Lions* from the *Funerary Monument to Clement XIII* were bequeathed to the Gallerie.

The works are displayed on the ground floor of the Gallerie, in the loggia, an inner room and the tablinum. In addition to some sculptures, this latter room also contains the *Monument to Antonio Canova*, a porphyry amphora from the Treasury of St Mark's, which until 2018 preserved the sculptor's hand (this is now in a monument in the Tempio at Possagno (TV). EC

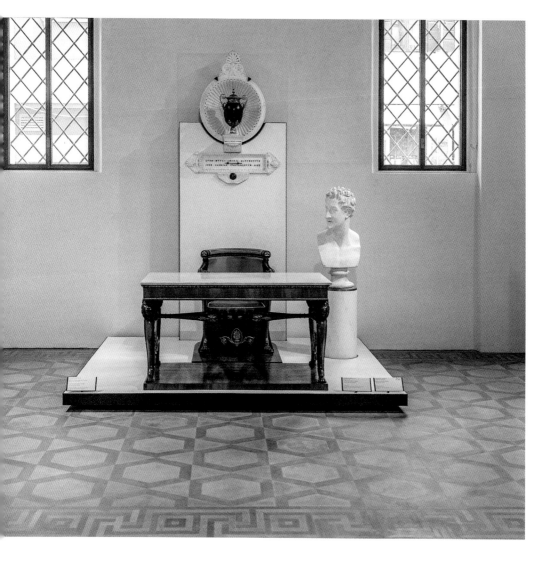

• Bust of Leopoldo Cicognara

1821–1822, plaster model

This marble bust of Count Cicognara was commissioned from Canova in 1818 by this count's wife. The artist set to work in the winter of 1821–1822, when the Cicognara family was in Rome. The terracotta model was made directly by Canova, while work on the marble was never completed due to the his sudden death. Once the marble arrived in Venice, Cicognara put it on a pedestal in the great hall, next to the *Bust of Canova* and beside the table with the *Bust of Beatrice,* a gift from Canova. After Cicognara's death in 1834 the family decided to place the count's marble bust in the family chapel in the Ferrara cemetery. The plaster model remained at Cicognara's house at the Procuratie Vecchie until his death. In his will the count arranged for it to be donated to the Accademia di Belle Arti di Venezia, of which he had been president for many years. EC

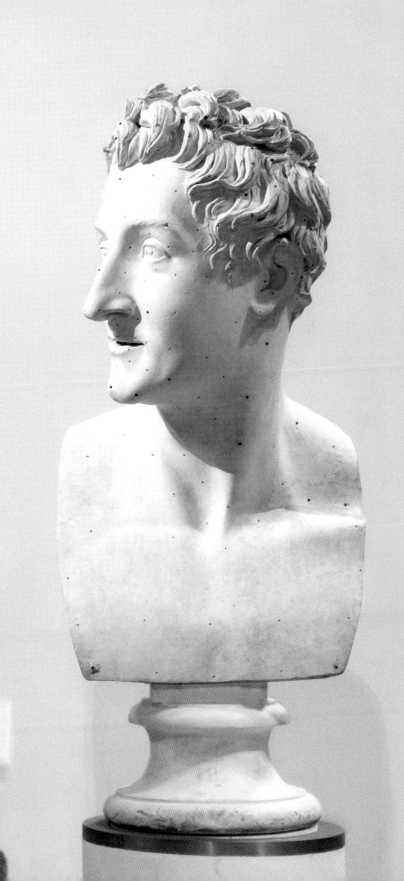

• Kreugas

1796–1801, plaster cast

Kreugas and *Damoxenos*, two boxers, were not made to a commission. In these workes Canova experimented with new forms of expression, departing from the genre of the graceful and the ideal nude (*Venus and Adonis, Cupid and Psyche, Mary Magdalene...*) typical of his work in the late eighteenth century. The boxers along with the *Perseus Triumphant* were purchased by Pope Pius VII for the Vatican Museums and considered worthy to replace the masterpieces of ancient statuary, such as the *Apollo Belvedere*, the *Torso* and the *Laocoön*, which where transferred to the Louvre after the Treaty of Tolentino. The two colossi marked a new departure in Canova's work, that of the heroic genre distinguished by a more severe style, intense pathos and a more agitated formal rendering, very different from the extenuated modulation of the surfaces and the luminist-chromatic studies in his earlier works. He sought to depict unusual actions and feelings found in mythological episodes seldom represented by artists. The two boxers appear in an episode narrated by Pausanias. After a day spent in combat, since no winner was found, it was decided to allow each one last blow. Canova shows us *Kreugas*, who has just struck his opponent on the head and holds his left hand clenched on his head. His face is serene; his legs set wide apart give his body an extraordinary tension, while he awaits the mortal blow from his rival, to whom he offers his side. His opponent Damoxenos deals Kreugas a terrible blow that proves lethal. Damoxenos is condemned to exile while a statue is erected to Kreugas in the temple of Jupiter Lycaeus in Arcadia.

Canova considered *Kreugas* a manifesto of his art and the new heroic genre. He therefore chose it as a representative work to be sent as a cast to the major Academies of Europe. This specimen, sent to Venice in 1802, was an example of his promotional effort. EC

The museum, after being located in Palazzo Correr and the Fondaco dei Turchi, was definitively transferred to St Mark's Square in 1922. The Canova collection consists of works (drawings, paintings, sketches and sculptures in plaster, stone and marble), personal objects and mementos that recount the whole course of Antonio Canova's achievement. The collection was assembled in different years, through donations or purchases. The works came from collections owned by people who were in contact with Canova (Sartori, Cappello, D'Este, Falier, Farselli, Franceseconi, Giustiniani, Pisani, Renier, Zardo...).

Since 1922 the collection has been in the neoclassical rooms of the Procuratie Nuove, which were recently carefully restored and the display redesigned, to continue to preserve, recount and exhibit one of the most important collections of his works. EC

• Orpheus and Eurydice

1775–1776, Vicenza stone

The two works were commissioned from the sculptor by Senator Giuseppe Falier. He had known Canova from an early age, since his grandfather Pasino had been one of the craftsmen employed on his villa in Asolo (TV). The statues were intended to decorate the garden of the villa, placed next to works by Giuseppe Bernardi, Canova's master. The garden of Villa Ca' Falier already contained *Diana and Endymion*, *Hercules and Omphale*, *Apollo and Daphne* and *Helen and Paris* all works with an amorous theme, for which Canova's piece was intended to form a companion piece. Unlike the works by his master Bernardi, Canova conceived the figures as separate and set on two pillars, related to each other at a distance. The first to be made was *Eurydice* (1775), followed by the figure of *Orpheus* (1775–1776). The two mythical figures are captured in attitudes of dramatic animation: *Orpheus*, turning desperately, sees his beloved *Eurydice* returning to Hades, seized by an infernal hand. Canova succeeded in conveying all the drama unfolding in the scene in the charged expressiveness of the features and gestures of the two figures (who were meant to be calling to each other at a distance).

The two works remained particularly dear to the artist, so that in 1815, when he was awarded the Marquisate of Ischia di Castro (a village north of Rome) and had to choose a coat of arms (which we find, for example, on the tomb in the Tempio Canoviano at Possagno), he chose the symbols of Orpheus and Eurydice, a lyre and a serpent.

To protect the works, they were placed inside the villa and then purchased by the museum from the Falier heirs in 1956. Also from the Falier collection and exhibited in the museum is the original model of *Paris* with its pointing up, a bequest from the artist. EC

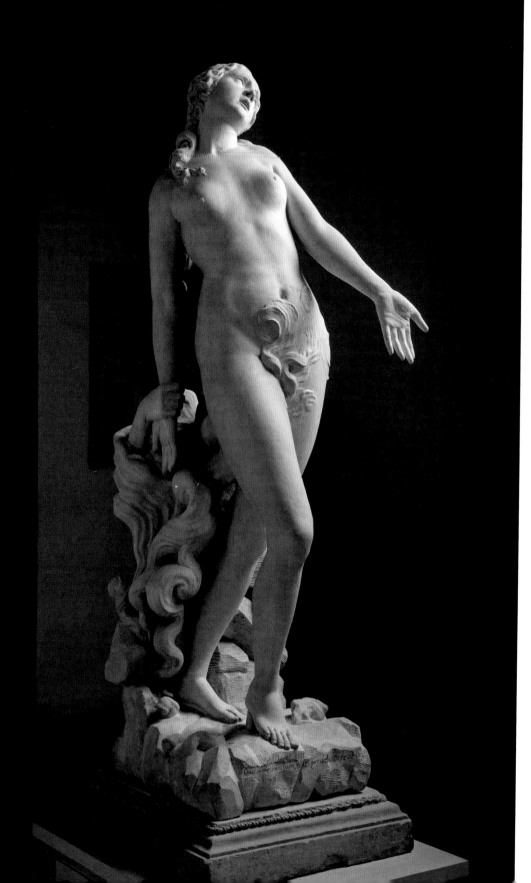

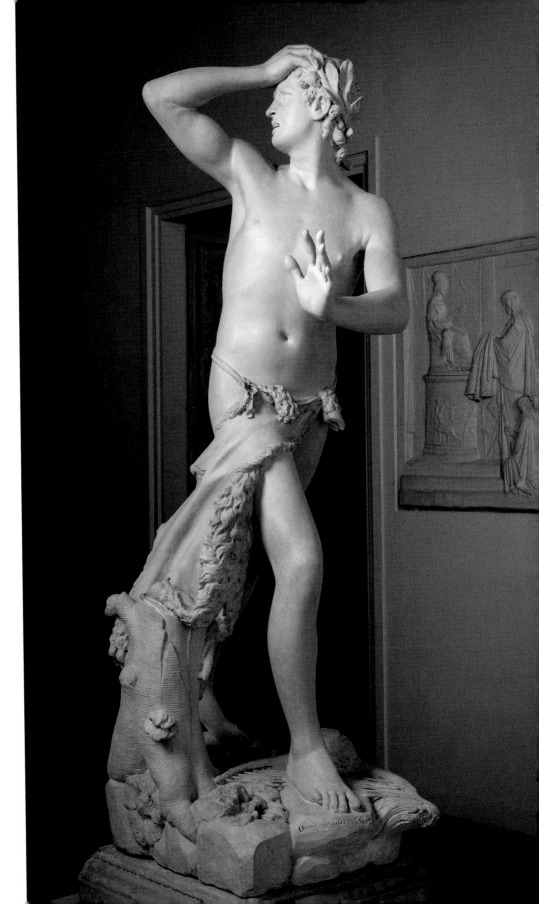

• *Daedalus and Icarus*

1777–1779, marble

The sculpture of *Daedalus and Icarus* was made in Venice for the procurator Pietro Vettor Pisani, who intended to place it in a niche between two gates at the entrance to his palazzo at San Polo on the Grand Canal. This sculptural group was extraordinarily successful when it was presented at the fair of the Sensa, organized on the feast of the Ascension in St Mark's Square. After this it was placed in the hall of Palazzo Pisani Moretta. From the outset, it was considered the masterpiece of Canova's youth and a turning point in his career. For the first time the sculptor used the working method that later became customary with him. He first made a small model (viewed and approved by the client); then he made a full-size model in plaster from which, with the pointing-up system and the help of a stonemason, he roughed out the marble. The choice of subject itself was new and rarely represented in sculpture, though more frequently in painting. The work depicts Daedalus waxing the wings of his young son Icarus to enable him to escape from the labyrinth of Crete, which he himself built and where they are now imprisoned. The work rests on the felicitous contrast between the naturalistic and clearly characterized figure of the elderly father and the ideal representation of the son. Daedalus, bearing all the signs of time, is represented as balding, with wrinkles of care and concentration in his face and sagging skin; Icarus is smiling and carefree. From the base on which their feet rest project the wings, the mallet and chisel that enable us to interpret the work as an allegory of the sculpture, but also as autobiographical homage. The features and ages of the two figures have further suggested that it may contain an allusion to his grandfather Pasino, who taught his young nephew Antonio the art that enabled him to take flight.

The sale of the sculpture brought Canova the one hundred sequins that he needed to pay for his trip to Rome. A guest at the Venetian embassy in Palazzo Venezia, in June 1780 he had a cast of the work sent (now in the Museo Gypsotheca at Possagno) to present it to the art experts, who offered him lukewarm appreciation.

Also from the Pisani collection is the *Amorino* now in the Throne Room of the museum. EC

Following pages: Throne Room with works by Canova, Venice, Museo Correr.

ANTONIO BOSA, GIUSEPPE DE FABRIS,
GIACOMO DE MARTINI, BARTOLOMEO FERRARI,
RINALDO RINALDI, LUIGI ZANDOMENEGHI
AND DOMENICO FADIGA

Funerary Monument to Antonio Canova

1823–1827, Carrara marble

On the same day that Antonio Canova's funeral was held in Venice, on 16 October 1822, three days after the supreme sculptor's death in the city, its academic body, chaired by Leopoldo Cicognara, opened a a Europe-wide subscription list for a splendid monument to honour the artist. It was to be erected in Venice, a city where Canova had learned the rudiments of the art from his master Giuseppe Bernardi Torretto; here he had met the noble patrons who supported him in achieving such greatness, and here, finally, his industrious life had come to an end. The monument was intended to enshrine for posterity the glory that the world of his time had recognized and also the great nobility of his soul.

It was decided to make use of a work conceived by Canova. Preserved at the Accademia was one of the wooden models of the funerary monument to Titian, conceived and made by Canova for the Basilica of Santa Maria Gloriosa dei Frari. It was commissioned by his Venetian patron, the cavaliere Girolamo Zulian in 1794, but his death and the fall of the Republic had prevented the project from coming to fruition.

Six of the most illustrious Venetian artists associated with Canova in various ways were chosen for the work. Giuseppe De Fabris, encouraged at the start of his career by Canova himself and active in Rome, sculpted the figure of *Genius* seated on the steps at the front of the pyramid. Rinaldo Rinaldi, an assistant to Canova, also resident in Rome, executed the *Lion* and the *Genius of Sculpture*. Antonio Bosa, a sculptor from Pove del Grappa (TV), was commissioned to produce the bas-relief of the medallion that encloses the image of Canova in profile and the two allegories of *Fame* that support it. Bartolomeo Ferrari, originally from Marostica (VI), sculpted the statue personifying *Sculpture,* while Giacomo De Martini, a Venetian, executed the two *Genii* that follow the statues of *Painting* and

Architecture sculpted by Luigi Zandomeneghi. The pyramid was carved by the skilled stonemason Domenico Fadiga. The sculptor's heart was placed in the monument.

The monument to Canova was unveiled on 1 June 1827 in the Basilica of Santa Maria Gloriosa dei Frari after a funeral mass written and celebrated by Abbot Antonio Marsand. The ceremony was attended by Venice's civil and military authorities, the aristocracy and all the men of letters. On record are the deep feelings of the sculptor's brother, Abbot Giovanni Battista Sartori, and Leopoldo Cicognara who gave a brief speech to commemorate his lost friend. Opposite the cenotaph of Canova in the following years (1842–1852), Luigi Zandomeneghi with his sons Pietro and Andrea sculpted the *Monument to Titian* in neo-Renaissance style.

EC, VP

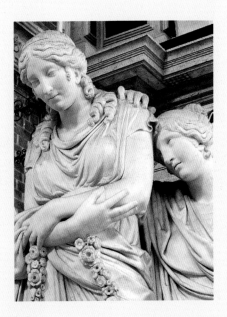

CANOVA

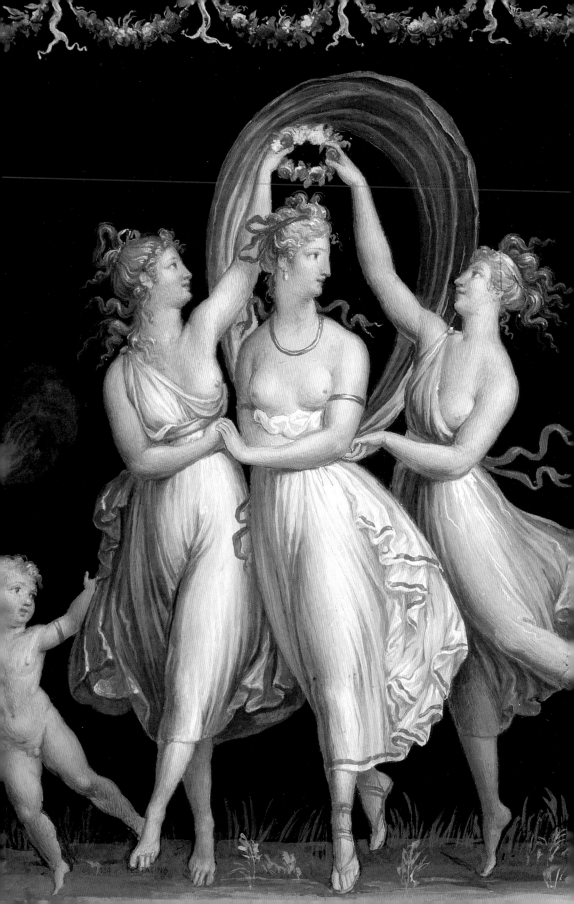

Timeline: life and works of Antonio Canova

1757
1 November, Antonio Canova is born at Possagno (TV).

1761
His father Pietro dies; his mother Angela Zardo returns to Crespano del Grappa in the municipality of Pieve del Grappa (TV), his native town, leaving Antonio with his grandfather Pasino Canova and grandmother Caterina Ceccato.

1762
His mother Angela Zardo marries her second husband Francesco Sartori. They have four children: Giuseppe, Elisabetta, Maria and Giovanni Battista, the future bishop of Mindo.

1768
Through the good offices of the nobleman Giovanni Falier, Antonio is taken into the studio of the sculptor Giuseppe Bernardi called Torretto at Pagnano d'Asolo, a hamlet of the municipality of Asolo (TV), and later in Venice in his workshop at Santa Marina.

1769
Attends the Pubblica Accademia del Nudo, with premises at Fonteghetto della Farina near St Mark's Square.

1772
Sculpts two fruit baskets in stone for Senator Falier today in the Museo Correr.

1773
Starts work on the statues of *Orpheus and Eurydice* for Villa Ca' Falier at Pradazzi d'Asolo, today Villa d'Asolo, in the municipality of Asolo (TV), now in the Museo Correr.

1775
His brother Giovanni Battista Sartori is born at Crespano del Grappa (TV).
Antonio makes a copy of the *Wrestlers* in the Farsetti Collection (now in the Gallerie dell'Accademia).

1778
Begins *Daedalus and Icarus* for Senator Pietro Vettor Pisani (now in the Museo Correr).

1779
In May he exhibits the sculptural group of *Daedalus and Icarus* in St Mark's Square during the feast of the Ascension.
On 9 October he leaves for Rome, where he is the guest of the Venetian ambassador Girolamo Zulian at Palazzo Venezia.

1780
On 22 January he sets off on a tour of the archaeological sites of Pompeii, Herculaneum and Paestum.

1781
Settles permanently in Rome.
Obtains the three-year pension that the Venetian State gives to deserving young Venetian artists. Ambassador Zulian commissions a statue on any subject of his choice; he sculpts *Theseus and the Minotaur* (London, Victoria and Albert Museum).

1783
Receives a commission for the funerary monuments to Popes Clement XIV (for the Basilica of the Santi XII Apostoli completed in 1887) and Clement XIII for St Peter's Basilica, inaugurated in April 1792.

1787
Receives a commission from the British Colonel John Campbell for the group of *Love and Psyche* (Paris, Louvre Museum).

1790
Signs and dates the *Self-Portrait* in the Uffizi.

1792
First return to Possagno (TV), where he is welcomed triumphantly by the citizens.
He returns to Venice where he receives a commission for a monument to the memory of Admiral Angelo Emo (Venice, Museo Storico Navale della Marina Militare).

1796
Completes the model of *Hercules and Lichas*.
In Rome, Faustino Tadini publishes *Le sculture e le pitture di Antonio Canova*, the first book devoted to the artist.

1797
After the fall of the Republic of Venice, General Napoleon Bonaparte writes to Canova assuring him that he is under the protection of the Army of Italy.

1798
In May he is at Possagno (TV).
He travels through Austria and Germany with Prince Abbondio Rezzonico.
In Vienna he receives a commission for the *Monument to Maria Cristina of Austria* (Vienna, Augustinerkirche).

1799
In spring he is at Possagno (TV), where he devotes himself to painting, producing the great *Lamentation Over the Dead Christ* for the parish church (now the Tempio Canoviano at Possagno). He signs and dates the paintings of *The Graces*, *Charity* and *Self-Portrait as a Sculptor* (Casa Canova) and *Hercules Slaying his Children* in the Museo Civico of Bassano.

1800

Appointed a member of the Accademia Nazionale di San Luca in Rome.

In May Giovanni Battista Sartori moves to Rome to live with his brother, acting as his secretary.

1802

Appointed Inspector General of the General Advisory Commission of Antiquities and Fine Arts of State and Church, of the Accademia Nazionale di San Luca, of the Vatican Museums and of the Capitoline Museum. After a first refusal, on 19 September he leaves for Paris to sculpt a portrait of the First Consul Napoleon.

1803

Completes the model of the statue of *Napoleon as Mars the Peacemaker*.

1804

Receives a commission from the Countess of Albany for the *Funerary Monument to Vittorio Alfieri* in the Basilica of Santa Croce in Florence (unveiled in 1810); he produces the *Venus Italica* for the Palatine Gallery, also in Florence and completed in 1812.

Prince Camillo Borghese requests a statue of his wife, Napoleon's sister, of *Pauline as Venus Victrix*.

1805

Executes the model for the statue of Napoleon's mother Letizia Ramolino Bonaparte.

Receives a commission from the Russian Count Paul Romanzow to sculpt a statue of *Peace*, completed only in 1814 (Kyiv, National Museum of Art).

1806

Completes the statue of *Napoleon as Mars the Peacemaker* (London, Apsley House).

1807

Completes the stele of his friend Giovanni Volpato in the Basilica of the Santi XII Apostoli in Rome.

1808

Completes the statue of Pauline Bonaparte (Rome, Galleria Borghese).

1810

In July Canova is in Venice and then at Possagno (TV) where he retouches the altarpiece of the *Lamentation*. In autumn he is summoned to Paris to paint the portrait of Marie Louise of Habsburg-Lorraine, the emperor's new wife.

Napoleon offers to make Canova superintendent of the arts, a member of the Legion of Honour and a senator, but he refuses.

1812

In February he sculpts the marble *Self-Portrait* now in the Tempio Canoviano at Possagno.

Josephine de Beauharnais commissions *The Graces* completed in 1816 (Saint Petersburg, Hermitage).

1815

Appointed pontifical delegate for the restitution of artworks taken by the French. He goes to Paris to select paintings and sculptures to bring back to Italy. On 1 November he is in London with his brother to see the Parthenon marbles in Lord Elgin's collection. The following year, thanks to Canova's influence, the sculptures of Phidias are purchased by the British parliament and exhibited at the British Museum.

1818

Completes the model of the statue of George Washington commissioned by the State of North Carolina (USA) for the State House in Raleigh (the statue was destroyed by a fire in 1831).

1820

In January he suffers from severe abdominal pain. In spring he is again in Venice and Possagno (TV).

1821

His health deteriorate. He completes the statue of George Washington and in July he is in Padua, in August at Possagno (TV).

1822

On 17 September he again arrives in Possagno (TV) and falls ill.

On 4 October he is in Venice. His stomach pains become more acute. Antonio Canova makes a new will appointing his brother Giovanni Battista Sartori his universal heir.

The artist dies at 7.43 a.m. on 13 October. An autopsy reveals a deformation of the stomach due to the excessive use of the sculptor's drill resting on the wall of the thorax.

He is given an official funeral in St Mark's Basilica on 16 October.

1826

Giovanni Battista Sartori sells the studio in Rome and in 1829 has all of Canova's works and documents moved to Possagno (TV).

1827

The monument to Canova in the Basilica of Santa Maria Gloriosa dei Frari is inaugurated.

1830

The Tempio Canoviano at Possagno is consecrated.

1858

Giovanni Battista Sartori dies at Possagno (TV).

VP

Index of places

Index of names

Allegories and mythological figures
given in italics

Selected Bibliography

The Canova bibliography is vast and highly specialized. We have therefore decided to provide a list of some of the more essential canonical texts as well as a selection of the most recent works whose own bibliographical notes might prove useful to those wishing to conduct further research, thus leaving them free to devise their own personal course of study and to discover and appreciate Antonio Canova's works in the Veneto.

G. Pavanello, *L'opera completa del Canova*, Milan 1976.

Venezia nell'età di Canova, 1780–1830, catalogue of the exhibition, edited by E. Bassi, A. Dorigato, G. Mariacher, G. Pavanello and G. Romanelli, Venice 1978.

Antonio Canova, catalogue of the exhibition, edited by G. Pavanello and G. Romanelli, Venice 1992.

Canova, catalogue of the exhibition, edited by S. Androsov, M. Guderzo and G. Pavanello, Milan 2003.

Canova e la Venere vincitrice, catalogue of the exhibition, edited by A. Coliva and F. Mazzocca, Milan 2007.

Canova alla corte degli Zar. Capolavori dell'Ermitage di San Pietroburgo, catalogue of the exhibition, edited by S. Androsov and F. Mazzocca, Milan 2008.

Canova l'ideale classico tra scultura e pittura, catalogue of the exhibition, edited by S. Androsov, F. Mazzocca and A. Paolucci, Cinisello Balsamo (Milan) 2009.

Venere nelle terre di Canova, catalogue of the exhibition, introduction by H. Honour, edited by M. Guderzo, Crocetta del Montello (Treviso) 2015.

Canova e l'Antico, catalogue of the exhibition, edited by G. Pavanello, Milan 2019.

Canova. Eterna bellezza, catalogue of the exhibition, edited by G. Pavanello, Cinisello Balsamo (Milan) 2019.

Canova Thorvaldsen. La nascita della scultura moderna, catalogue of the exhibition, edited by S. Grandesso and F. Mazzocca, Milan 2019.

Museo Gypsotheca Antonio Canova, edited by M. Guderzo, Cinisello Balsamo (Milan) 2020.

F. Leone, *Antonio Canova. La vita e l'opera*, Rome 2022.

See also the volumes published by the Comitato per l'edizione Nazionale delle Opere di Antonio Canova and the contributions published in the journal *Studi neoclassici* and previously in the proceedings of the conferences organized by the Istituto di ricerca per gli studi su Canova e il Neoclassicismo.

Useful information

Opening hours may be subject to variation. Visits to churches are suspended during services. Visitors may have to pay an admission charge.

ALTIVOLE

Parish church San Vito e Compagni martiri
piazza San Vito 1 – 31030 Altivole, Treviso

ASOLO

Museo Civico di Asolo
via Regina Cornaro, 74 – 31011 Asolo, Treviso
www.museoasolo.it

Parish church of Pagnano d'Asolo
via dei Torretto 13, località Pagnano d'Asolo
31011 Asolo, Treviso

BASSANO DEL GRAPPA

Museo Civico di Bassano del Grappa
piazza Garibaldi 34 – 36061 Bassano del Grappa, Vicenza
www.museibassano.it

PADUA

Musei Civici agli Eremitani
piazza Eremitani, 8 – 35121 Padua
www.padovamusei.it/musei/museo-arte-medievale-moderna

Museo Bottacin
Palazzo Zuckermann
corso Garibaldi 33 – 35121 Padua
www.padovamusei.it/musei/museo-bottacin

Prato della Valle
Prato della Valle – 35121 Padua

Palazzo Papafava dei Carraresi
Not visitable

PIEVE DEL GRAPPA

Cathedral of Crespano del Grappa – Church of Santi Marco e Pancrazio
piazza Antonio Canova, 46, località Crespano del Grappa – 31017 Pieve del Grappa, Treviso

Sanctuary of the Madonna del Covolo
via Madonna Del Covolo, 148 – località Crespano del Grappa – 31017 Pieve del Grappa, Treviso

POSSAGNO

Museo Gypsotheca Antonio Canova
via Canova, 74 – 31054 Possagno, Treviso
www.museocanova.it

Tempio Canoviano
via Stradone del Tempio – 31054 Possagno, Treviso
www.tempiocanoviano.it

VENICE

Basilica of Santa Maria Gloriosa dei Frari
San Polo, 3072 – 30125 Venice
www.basilicadeifrari.it

Church of Santo Stefano
Campo Santo Stefano – 30100 Venice
www.chorusvenezia.org

Congregazione Armena Mechitarista
Isola di San Lazzaro degli Armeni – 30170 Venice
www.mechitar.org

Fondazione Querini Stampalia
Campo Santa Maria Formosa, 5252 – 30122 Venice
www.querinistampalia.org

Gallerie dell'Accademia
Campo della Carità, 1050 – 30123 Venice
gallerieaccademia.it

Museo Correr
Piazza San Marco, 52 – 30124 Venice
www.correr.visitmuve.it

Museo Storico Navale della Marina Militare
riva San Biasio, 2148 – 30122 Venice
www.visitmuve.it/it/musei/museo-storico-navale-di-venezia

Pinacoteca Manfrediniana Diocesan Museum
Dorsoduro 1 – 30123 Venice
www.seminariovenezia.it/cms/pinacoteca

House where Antonio Canova died
Bacino Orseolo, Ponte Tron – 30124 Venice

Fonteghetto della farina
now the premises of the Direzione Marittima di Venezia
San Marco 1324/A – 30124 Venice

Studio of Antonio Canova at San Maurizio
Ca' Granda – Palazzo della Prefettura
San Marco, 2661 – 30124 Venice
Not visitable

VERONA

Galleria d'Arte Moderna Achille Forti
Cortile Mercato Vecchio, 6 – 37121 Verona
www.gam.comune.verona.it

Casa Museo Palazzo Maffei
Piazza delle Erbe, 38 – 37121 Verona
www.palazzomaffeiverona.com

VICENZA

Former monastery of San Pietro – Now Residenza Ottavio Trento
piazza San Pietro, 9 – 36100 Vicenza

Reproduction
Opero S.r.l., Verona

Printing
L.E.G.O. S.p.A., Vicenza

for Marsilio Editori® s.p.a., Venezia
www.marsilioeditori.it